Aimed at parents and caregivers, this book explores the meaning and value of drawing for youngsters, from toddlers aged two to pre-adolescents aged twelve. Informed by psychology and practical teaching with children, it guides readers through the progressive stages and characteristics of drawing development as children change mentally, physically, socially, emotionally and creatively. It offers tips to encourage children to express their ideas visually and recommends age-appropriate art materials, workspaces and different media. It also gives suggestions for making a museum visit more meaningful – not to mention more fun – for both parents and kids. Packed with delightful examples of children's art, *Children Draw* is an essential book for parents interested in their child's art activities.

Children Draw

A guide to why, when and how children make art

Marilyn JS Goodman

REAKTION BOOKS

Published by Reaktion Books Ltd
Unit 32, Waterside
44–48 Wharf Road
London N1 7UX, UK
www.reaktionbooks.co.uk

First published 2018

Printed and bound in China by 1010 Printing International Ltd

A catalogue record for this book is available from the
British Library

ISBN 978 1 78023 989 7

Photos by: B. Diner: p. 19; A. Van Straaten: p. 78;
V. Young: pp. 80, 122; H. Garvey: p. 142; D. Dolmao: p. 145;
J. Mandle: p. 151; R. Bustamante: p. 155.

Contents

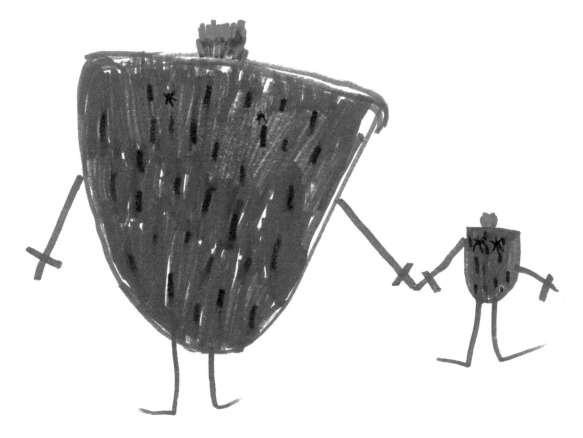

'Walking Strawberries', by Nelly, aged 5–6, delightfully reimagines a happy, secure, guiding relationship between a grown-up strawberry and a younger strawberry.

Introduction

What do we see when we look at children's drawings? Parents, caregivers and adults are delighted and intrigued by the drawings of young children but often have questions as to why children draw what they do, when they do and in the way that they do. For example, why do toddlers seem to enjoy scribbling so much? Why does my five-year-old draw things floating all around the page? Why is it that youngsters draw pictures of houses with pointed roofs, chimneys, cross-paned windows and yellow suns with lines radiating outwards? Or why is it that my ten-year-old will no longer draw anything other than figures copied from comic books or fashion magazines? If any of these questions piques your parental interest, this book is for you.

For youngsters aged two to twelve, expressing themselves through art is a very powerful thing. Children use drawing as a visual language – a language of thought that helps them learn, and one that continually evolves as they grow. Children's art offers clues to what they like and dislike, what they fear and what they desire and,

most importantly, what they value and what they understand or have accomplished. Their drawings are serious attempts to give form to their environment, express something about it, and present it in a way that is truly meaningful. Their art reveals how they see, think and feel at that very moment in time. Fortunately, parents can learn much about their children just by looking at their drawings and watching them as they work.

Children intuitively begin making marks typically by the time they reach their second year. At first, they simply enjoy the physical sensations of moving or jabbing a crayon on a sheet of paper. But soon they make the connection between their movements and the marks they produce. After a while, lines become shapes, shapes are combined into patterns, and scribbles that resemble something in the real world may even be given names. All the while, the child is developing a personal vocabulary of lines and forms that will become the basis of his or her visual expression. However, older children tend to lose interest in drawing as their primary mode of self-expression, preferring instead writing, language, sports, games and other social endeavours, which today usually includes digital and online communication. Moreover, children who do draw seem determined to depict things as realistically as possible. Only certain youngsters, perhaps those with particular talent and the right encouragement, return to drawing after they reach adolescence.

Why is it important for children to create? Because they learn a lot while doing so. Art is an integral activity to a child's development. It allows children to discover, explore, experiment and learn independently, even if that learning is simply about the different marks a crayon makes when more or less pressure is applied with it. Making art and, more specifically, drawing with a variety of mediums encourages children to figure out how they feel about themselves and things around them. It enables them to give form to their ideas

and experiences while helping them solve problems and develop skills necessary for both creative and critical thinking. It helps them express their personality and communicate something about themselves and their world to others. And it helps them develop a positive self-image and become happy, secure and fearless human beings. If you have any doubts about this, just think back and recall how happy you were in preschool or nursery when you were encouraged to express yourself creatively.

In the process of gathering materials for this book I had the opportunity to speak to many parents and caregivers about their children's drawings and the possibility of sharing some of these images with the world at large. In addition to the parents whose children currently fell within my two-to-twelve-year age range, there were other parents who had lovingly preserved early samples of their children's drawing, even though their offspring had grown well into their teens or, in several cases, were now artists, engineers or architects. At the same time, I found out quite a bit about their children's drawing practices. What surprised me most was how many parents said that their children only drew while at school. First, not encouraging children to draw at home can send an odd message, suggesting something like 'we don't care about what's important to you, what you want to express or what you think about things', even if that isn't at all true. Second, while drawing, painting and art experiences are typically part of every preschool day, it is not part of every school experience. Fortunately, art is still mandated as an integral part of the primary school curriculum in the UK. But in some circles it seems to be thought of as an increasingly unnecessary 'frill' and less important than other subjects. Unfortunately, the number of elementary schools that still offer special art classes in the USA has decreased dramatically in recent years. This is partially due to a lack of funding. But it is also a reflection of an ongoing obsession in the USA with standardized test scores. For

the most part, art classes in primary schools offered by qualified art teachers are an endangered species – not to mention the scarcity of art supplies, such as crayons and drawing paper. Parents and care-givers must supplement these school experiences and provide back-up support to ensure their children's growth and development.

Illustrated throughout this book are works of art made by chil-dren of varied ages using a multitude of drawing mediums. Today, art materials for children are much more diverse than in the past, and even the essence of the humble 'crayon' can be so much more complex than a simple stick of coloured wax. Some 'drawings' have obviously been created using paints. Unlike adult artists, children have not studied or practised perfecting their painting techniques. Instead, almost all young children use paints to 'draw' with liquid colour. And filling large spaces on a sheet of paper with paint is sometimes so much easier than it is with a skinny crayon or marker. Hence, I have included a number of painted drawings in this book.

Children Draw is divided into three parts and is intended for parents and caregivers who want to know more about their chil-dren's drawings. It does not offer sample lesson plans on teaching drawing to children. Nor does it offer any step-by-step instructions for arts and crafts projects. Instead, it provides concise information for parents about the meaning and value of drawing for youngsters aged two to twelve, and the progressive stages and characteristics of drawing development as children naturally grow and change physically, emotionally, intellectually, socially and aesthetically.

Part One, 'Why?', is all about decoding children's drawings. Most importantly, it discusses children's natural impulse to draw and the significance of drawing to their overall development. Additional topics address whether or not a child's drawing should be considered to be a work of art; sources of children's inspiration; disturbing subject-matter; and an explanation of how children use drawing as a visual language.

Also included is a brief overview of those who first researched, collected or wrote about children's drawings and how children's drawings relate to their cognitive development and general education.

Part Two, 'When?', presents a guide for parents through the progressive stages of children's artistic expression and offers easy-to-spot characteristics of what and how children draw at each stage of their artistic development.

Part Three, 'How?', offers realistic tips on how parents can encourage their children's drawing at home by providing appropriate space, materials and opportunities, not to mention the right attitude and support. It covers some dos and don'ts regarding children's art exhibitions and competitions, and about colouring books, copying and stencils; and advice about digital drawing apps and devices for kids. Last, it offers numerous suggestions for making an art museum visit more meaningful – and of course way more fun – both for parents and kids. Exposing children to new art experiences and then discussing them – together – can cultivate imagination and creativity. These experiences can promote growth, increase knowledge and also encourage children to perceive and enjoy the world around them using all their senses.

Why?

Every child is an artist.
The problem is how to
remain an artist once
you grow up.

Pablo Picasso

Why?

Decoding Children's Drawing

Young children have always had the innate desire to express themselves creatively, and undoubtedly there have always been those who were fascinated by their creative output. Kirk Varnedoe, the late former chief curator of painting and sculpture at the Museum of Modern Art in New York, wrote that twentieth-century artists were particularly attracted to children's art, not only because of some romanticized Western notion of childhood as an innocent, natural state of grace, but because the immediate candour and simplicity of children's renderings were thought to spring from an unfettered 'language of the mind'. While no one is attempting to equate the scribbles and drawings of young children with the deeper complexity of works made by modern and contemporary artists, we only have to view the automatic drawings of the Surrealist André Masson, the gestural expressions of painters such as Franz Kline or Jackson Pollock, the graffiti-like scrawls in the work of Cy Twombly or the turbulent, calligraphic brush-strokes in Julie Mehretu's paintings to sense a visceral connection between the two.

A Bit of History, or Who Cared?

Few individuals delved seriously into the study of children's drawings prior to the mid-nineteenth century, probably because drawing was commonly thought to be a harmless activity that also just happened to be something children seemed to enjoy doing. Nevertheless, there were a few well-meaning early educational reformers who supported the teaching of drawing to children in schools, suggesting that such instruction could help improve penmanship and possibly foster skills that might lead to a future vocation in the trades.

In the late nineteenth and early twentieth centuries, a feeling of change swept across Europe and the United States. Some social reformers sought to improve the health, welfare and, most importantly, the education of children, with the belief that this effort would help to improve overall conditions for society in general. A child study or experimental pedagogy movement emerged with the intent of examining 'normal' child development. This movement initially included an array of interested participants, at first welcoming the involvement of teachers, parents, ministers, psychologists, school administrators, school counsellors, physicians and psychiatrists. Later on, in an effort to make child development (also known as developmental psychology) a more respectable field, laboratory schools were established, offering greater opportunities for controlled observation and study. Tests, especially those related to intelligence and academic achievement, were developed and administered. And previously accepted laypeople were now excluded from having an equally respected voice in the movement.

Around the same time, there was also growing interest in determining how drawings might somehow correlate with the nature of those who created them. In Europe, for example, there were a number of practitioners who believed that drawings made by institutionalized adults with mental disorders could be used as diagnostic tools. Their theory was that the drawings offered insights into these patients'

psychological states, and that they might in turn be helpful tools to support patient rehabilitation.

Meanwhile, there were individuals who collected, exhibited, studied and/or wrote specifically about children's drawings, although often from a relatively subjective point of view and sometimes using a very limited sample, which in a few cases meant only drawings created by their own children. However, one Italian art historian, Corrado Ricci, exhibited a collection of 1,250 children's drawings. His interest in systematically analysing and classifying them led to the very first book on children's art, *L'arte dei bambini,* which he published in 1887. Around the same time, in England, the psychologist James Sully and the noted art educator Ebenezer Cooke began establishing their own taxonomies for children's creativity and drawing development, noting that children's drawings become more detailed and realistic as they grow. And in Vienna, Austria, the artist-educator Franz Cižek, who firmly believed that art made by young children was 'the first and purest source of artistic creation', began the Child Art Movement and opened his Juvenile Art Class in 1897.

In the early twentieth century the number of philosophers, psychologists, theorists and pedagogues who began studying and writing about children's drawings expanded, but now, most were using more scientific methodologies in order to achieve more conclusive (and respectable) results. During the same period, there was increasing interest in the work of two pioneers in the field of psychoanalysis: Sigmund Freud and Carl Jung. Some researchers were specifically drawn to the study of young children's art, examining the connections between what children draw and how children draw at different ages. It was thought that their findings might have significant implications regarding education. Many of these individuals identified and described three general stages of children's artistic development, often classified as: 1) a scribbling stage; 2) a schematic stage; and 3) a naturalistic or

realist stage. Others focused their work on how children's drawings might be used as measures of intelligence, growth and personality.

In the 1920s Sir Cyril Burt, a psychologist for the Education Officer's Department at London County Council, linked drawing with age and cognitive development. He wrote that 'tests of drawing' were among the most reliable indicators of mental growth, especially for those who were unable to express themselves through writing or speaking. In other words, because such tests were neither linguistic nor arithmetical, their advantage was that they did not rely on a child's ability to understand and manipulate abstract symbols such as words or numbers. Moreover, in looking over drawings made by the same child over the course of a year, Burt noted that it was possible to chart the child's mental, manual and imaginative development.

Four years later, the American child psychologist Florence Goodenough sought to supplement standard intelligence (IQ) tests with some sort of non-verbal scale of measurement. She developed her now famous Draw-A-Man test (first updated in the 1950s by Dale Harris as the more gender-neutral Draw-A-Person test, and again in 1963 as the Goodenough-Harris Drawing Test), which assesses a child's mental age – his/her visual, cognitive and motor skills – by asking the child to draw a human figure. The drawing is then scored based on both the quality and presence (or absence) of specific human figure features (such as ears or the number of fingers on each hand) against what would be considered 'typical' for that age. Although the original test has been revised many times over, the use of children's human figure drawings for intellectual, psychological and emotional assessment has been a popular and widespread practice, especially among psychologists and therapists. Meanwhile, other types of drawing tests, now referred to as 'projective techniques', have been developed as tools for use alongside psychological study and assessment.

While many others have studied and written about children's art, their artistic development and the teaching of art to children, perhaps the most widely respected textbook on children's artistic expressions is Viktor Lowenfeld's *Creative and Mental Growth*, originally published in 1947. While Lowenfeld's text has been updated and revised several times since his death (an edition was co-authored by W. Lambert Brittain in 1987), it remains tremendously influential in the field of art education even today, and it will serve as a point of departure.

Jesse, aged 8, drawing at home.

Why Do Kids Draw?

Every child has an instinctive desire to create. Without any prompting, children naturally and intuitively develop a powerful impulse to make marks and draw. Parents and caregivers can do their part to encourage this impulse by providing an age-appropriate drawing or writing tool, paper and a suitable spot for the child to work (preferably where an adult can keep an eye on things).

Young children delight in making their first scribbled marks on paper, just as they feel pride and a sense of accomplishment when taking their first steps or communicating verbally, even if they have a limited number of words at their disposal. They may even begin scribbling as early as eighteen months of age, when they are growing and developing their skills and abilities in many areas, including physical and motor, language and communication, social and emotional, and thinking and learning (cognitive). For most children, drawing is an adventure, a learning experience and, most importantly, a means of expressing their feelings and emotions. When they are a bit older, drawing allows children to organize and make sense of the world around them and figure out how they feel about things. They can experiment, develop symbols and concepts, and work things out for themselves in a visual way. According to Brittain, 'Art activities not only reflect a child's inner self: they help form it.'

Toddlers experience and learn about their environment through their senses and their physical activities. Art, in particular drawing and painting, allows children to use and fine-tune their sensory experiences, to explore and to make meaning of their surroundings. Not only does the physical sensation of drawing feel good, but handling art materials such as paint sticks, gel crayons or textured drawing paper feels luxurious.

Especially for young children with limited vocabularies, drawing serves as a universal language and is an effective way of expressing

and communicating their ideas, knowledge, thoughts and feelings to others. It allows children to grow linguistically in that it enables them to develop a visual language, leading to skills that will later be needed for reading and writing. As the child begins to scribble more and more, s/he realizes that a drawn symbol can represent something in the real world. Soon, the child announces that his/her circular scribble – a basic form drawn by all young children – is 'Mummy', 'Daddy', 'Cuddles the cat', or whatever or whomever else s/he decides it represents. As time goes on, more scribbled marks become eyes, the head becomes a face, and twig-like lines sticking out from the perimeter of the circle become arms and legs. The basic circular form is so useful to young children because it can mean whatever they want it to mean. And they can change its meaning whenever they feel like it.

For youngsters, drawing is a creative, absorbing and pleasurable activity that uses their ever-growing knowledge, changing observations and brand-new experiences. It is a language of thought that changes as the child grows, and one in which feelings, ideas, desires and emotions can all appear. Drawing is a way to give form to those ideas. It offers children opportunities to develop a positive identity while at the same time offering caregivers a window on to how children perceive themselves. In aiding with learning how to figure out relationships, drawing promotes the development of problem-solving and critical thinking skills that will serve the child later on.

Understanding Growth

One of Lowenfeld's key concepts is that a drawing or painting is an expression of the 'total' child at the time it was created. 'Each drawing reflects the child's feelings, intellectual capacity, physical development, perceptual awareness, creative involvement, aesthetic consciousness, and even the social developmental of the individual child' at that very

moment in time. As children develop and change, so do their drawings and paintings. Thus when the drawings of a child develop and change, it is an indication of the child's growth.

Drawings can offer opportunities for emotional growth, first, because they allow children to express how they feel about someone or something, and second, because they allow children to change their minds about the way they feel and express that as well. Moreover, drawings are a way for children to work things out and give visual form to their feelings. They allow children to confront their fears and tame

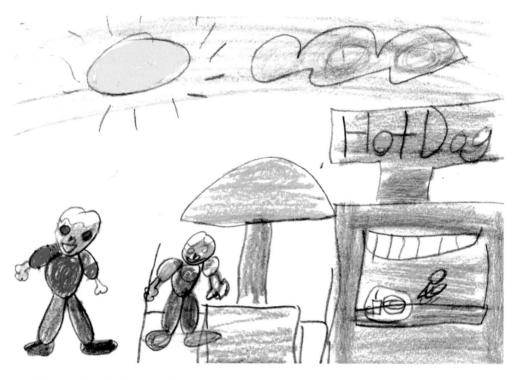

Santiago, aged 7–8, with his older brother. The explanation written on this is: 'Even though Patricio and I are brothers, we are alike in some ways and different in others. We are both kids. We are both boys. And we both like snowboarding.' While the brothers are drawn and dressed similarly, nothing more is mentioned about their relationship or the hot dog cart that appears so prominently.

'Mami and I Watch the Sunset', painted by Micaela, aged 8–9. The colours, the pose, the mother's arm around the daughter and the overall composition all convey love and a strong bond between the two.

'Mommy and Me' by Julian, aged 6–7. Notice the pose, the unique symbols used for the noses and how Mommy tenderly puts her arm around her son, whose arms reach out towards her.

them on paper, and to also show their love and happiness – feelings that might be difficult for some children to express in other ways. The degree to which children personally identify with their work is directly related to the intensity of their feelings. And when children appear in their own drawings, the intensity of their involvement offers greater opportunities for emotional growth. Interestingly, Jungian psychologists such as Greg Furth believe that children's inner and outer worlds sometimes overlap and that drawing enables children to 'escape' from the real world through creativity and play.

Drawing promotes intellectual growth as children become more aware of their surroundings. Indications of intellectual development can be seen in children's knowledge of their environment. More indications are linked to the manner in which they portray relationships between things in the environment. In other words, when children draw a world full of details, it signifies greater awareness and, thus, greater intellectual ability. As they increase their awareness and rendering of details, whether that means adding buttons on a shirt or branches on a tree, they are showing gains in their intellectual growth. In fact, a number of researchers feel that the development of children's artistic ability closely parallels their intellectual growth – at least up to the age of ten years.

One of the more observable types of growth is physical growth. Evidence of physical growth shows up via increased motor skills, such as the ability to grasp a crayon, draw within the edges of the paper, and progress from random scribbles to basic forms and beyond. As children get older, physical growth can be assessed by their ability to refine details in their work. Also, as children become increasingly aware of their own bodies, they are better able to portray physical actions and achievements.

Perceptual growth relates to how children absorb, organize and interpret sensory information, as well as to their increasing awareness

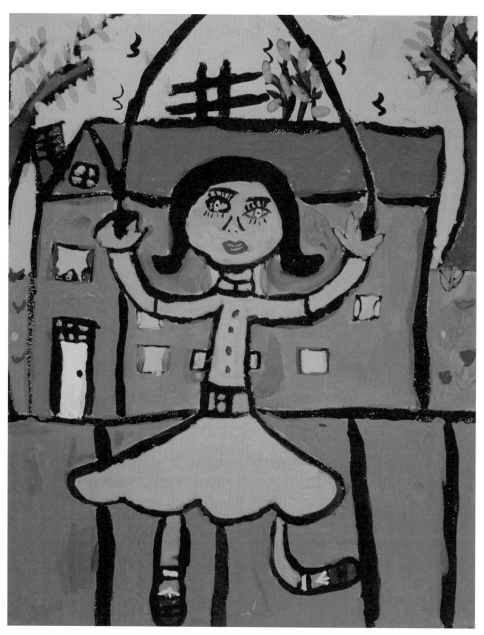

Painting from the 1970s of a girl playing with her skipping rope by Juliette, aged 8–9. Note how she depicts the blocks of the pavement and the house (with a doorknob and a TV antenna on the roof) and bends and stretches out the leg that needs to jump over the rope.

and use of perceptual experiences in their work. It can be seen in children's growing awareness and use of variations in colour, form and especially their perception and representation of physical space.

Children's drawings also offer clues about their social growth, in that they reflect a child's increasing awareness of his/her own experiences and an identification with the experiences of others. Typically, the first recognizable thing a child draws is a human person. As children grow, their drawings reflect a growing appreciation of people and relationships between people, and an expansion of social activities. Lowenfeld suggests that, in effect, the drawing becomes an extension of the child him/herself who is out in the real world with others.

A detailed and perceptive drawing of London by David, aged 5, that fills the entire page with activity.

Charles T., aged 6–7, imagines a flying machine with a broken propeller and a dragon inside.

As children depict people and scenes within their environment, their drawings offer insights into their growing social consciousness and understanding of the larger world. And as they learn to work with others, even if that only means sharing a bucket of crayons or chatting with the child on the other side of the easel, they gain important social skills. For older children, learning about the art made in other times or by other cultures increases their knowledge and understanding of others.

Children's aesthetic growth develops naturally and can be seen in the way they organize the elements and ideas in their drawings. It can also be seen in a more sophisticated use of the elements of art – line, shape, colour, texture and so on. Supposedly, as children grow aesthetically, the more harmonious their compositions will become. However, young children seem to organize the various elements in their drawings intuitively. Adolescents are more self-conscious about their work and may struggle with organization.

Popsicle, an imaginary orange dog with polka dots, created by Nelly, aged 5–6.

A wildly imaginative 'Super Cat', created with fun colours and stripes, pink eyes and an almost human-looking head and ears, walks in a fantasy garden. Laboriously drawn in markers by Oliver K., aged 7.

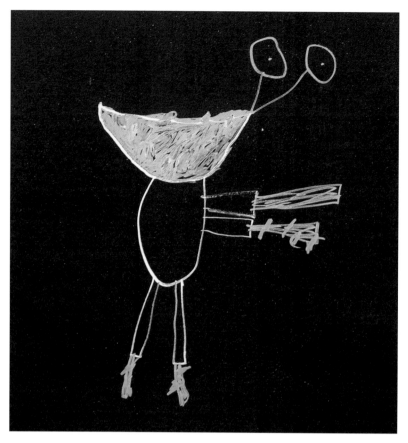

A bowl of pho (Vietnamese noodles) is reimagined as the head of an alien that has eyes protruding from its head, drawn weapons, and lightning bolts on its feet. Drawn on a blackboard with liquid chalk marker by Minh, aged 6–7.

Creative growth is evident the first time a child puts crayon to paper and draws scribbles. As children continue to grow, their ability to develop personal visual symbols and to translate ideas from their imagination onto paper increases as they also explore colours, lines, forms, shapes, textures and designs using a variety of materials. Ultimately, drawing promotes creative growth because during these valuable experiences, children can use their imaginations to give form to their fantasies, expressing themselves freely, honestly and spontaneously.

A Work of Art?

Art is not the same for kids as it is for adults. For young children in particular, art is not about someone else's pictures on the wall, but rather what they create themselves.

For children, drawing is a means of expression. Its value lies in the process rather than the product. To an adult, a child's drawing may seem naively charming or suggest a high degree of artistic talent. But a child's drawings should never be evaluated through the lens of adult aesthetics, because it is not about what adults see. Instead, a child's drawings are visual expressions that reveal how the child sees, thinks and feels about the world. In fact, to a certain degree, even adult artists reveal something of themselves in their work.

Parents should look at their child's drawing and try to understand the child's intention rather than judge the final product using the same parameters one might use to assess a work of art. When a grown-up tells a child that a drawing is 'great,' the child doesn't think 'great' refers to the drawing's aesthetic qualities. S/he assumes the adult understood what s/he was trying to convey.

In the same vein, since most parents and caregivers are not trained child psychologists or art therapists, they should not attempt to analyse or read anything into the child's art that isn't there. There was one child in my second-grade art class (aged seven to eight) who painted what seemed to be an incredibly sad brownish-grey rabbit with really long, droopy ears – a far cry from what some adults might consider a child's notion of a cute, snuggly, perky bunny rabbit and from the other 'happy' animals painted by his classmates. His classroom teacher suspected that the boy might be depressed and called his parents to find out if anything at home was amiss. As it turned out, the family had recently acquired a new pet – a lop-eared rabbit that actually looked very much like the one in the boy's painting.

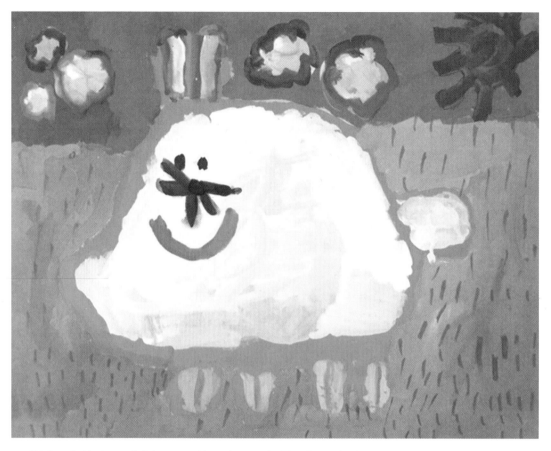

Painting of a big, happy, fluffy bunny outside on the grass by Rhonda, aged 7–8.

Just as enormous changes take place in youngsters' physical, emotional and intellectual development between the ages of two and twelve, there are also significant changes in their drawings and in their aesthetic awareness and preferences. For example, younger children seem to have an innate sense of composition in their drawing, filling the entire sheet with various elements, such as trees, houses, people, flowers, a sun, clouds, and so on. By the time they reach the age of nine or ten, they seem to be more concerned with how each element looks rather than where each element is placed. And by the time they

reach adolescence, they are increasingly critical of their own work and painfully aware of making things look 'right'.

Each new work of art reflects a child's growing and changing feelings, perceptions and sensitivities, as well as his/her social and aesthetic awareness, rapidly changing physical, emotional and intellectual development, and understanding and interpretation of the surrounding environment. And although there are general developmental milestones, parents must remember that childen move along at their own pace and always create according to their own interests, needs and abilities. For example, children growing up in a large city might draw elements of the human-made environment, such as tall buildings or bridges, because that is what they see and know. Or they might be interested in public transportation vehicles such as taxis, buses and subway trains, or fire engines, garbage trucks, cement mixers and police cars – things that are not as familiar to children who live elsewhere.

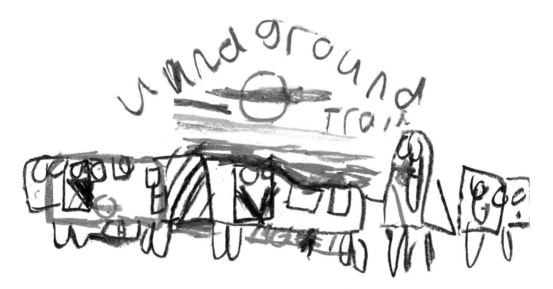

A very energetic depiction of a train in the London Underground, including Transport for London's graphic symbol, by David, aged 5.

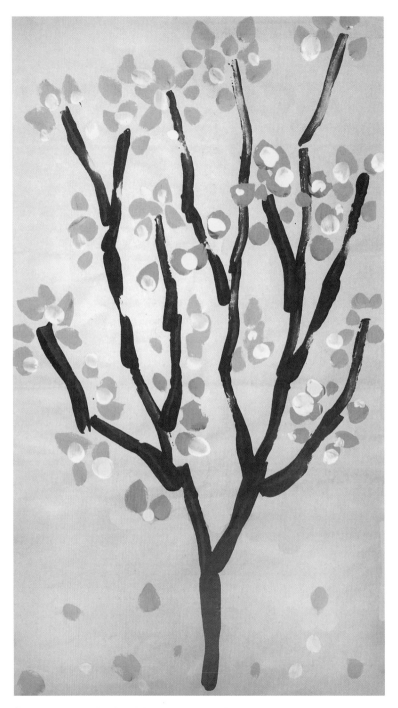

Simple but elegant drawing of cherry blossoms by Jazzlyn, aged 7, painted from direct observation.

'Missing Cat Bongo', drawn for a poster and carefully rendered in pencil by Isabelle, aged 10.

Sleeping dog, carefully observed and drawn directly from life by Patricio, aged 9.

An up-close view of a woodlouse drawn in pencil and paint by Charlie H., aged 5–6.

Sensitive drawing of lilies with cross-hatched shadows, by Orla, aged 8–9.
Such advanced detail implies excellent observation skills and art instruction.

A happy grasshopper by Grace, aged 5–6, reflects knowledge of the insect's anatomy, including its head, body, legs, wings and antennae.

Snail by Sebastian B., aged 6, drawn in pencil from direct observation.

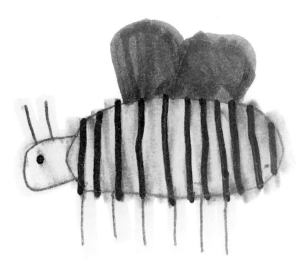

'Honeybee', pencil and marker drawing by Joshua, aged 8 (with delayed development). The drawing shows meticulous attention to details such as the wings, antennae and parallel black stripes on the body.

Meanwhile, a child growing up in a house near a park or with a garden may draw a greater variety of trees, leaves, insects and flowers because they have more exposure to them. And children who visit the zoo frequently, or who have a beloved pet at home, might be more interested in drawing animals. Most importantly, in each of these examples, children will draw what interests them. These may be representations from real life or simply from what inspires them. And since younger children usually do not have the patience, opportunity or inclination to draw something directly from observation, they are usually remembering pictures or photos in their mind's eye and depicting what is important to them.

Children who live in warm climates may see images of snow, reindeer and winter sports in movies and on television. But if they have never actually touched or seen snow, they probably won't be drawing snowy landscapes any time soon – other than around the

winter holiday season, that is. Of course, if children are lucky enough to go on a wonderful skiing trip with their family, chances are, with the right encouragement, they might make a drawing or painting about it. And here might be a good place to note that, regardless of how much parents say they want their children to draw, they are waging an uphill battle against a youth culture that seems to post and exchange photos of, well, everything. So if parents truly want their children to draw, they have to make certain their children know that their parents truly value not only the process of drawing but their actual drawings as well.

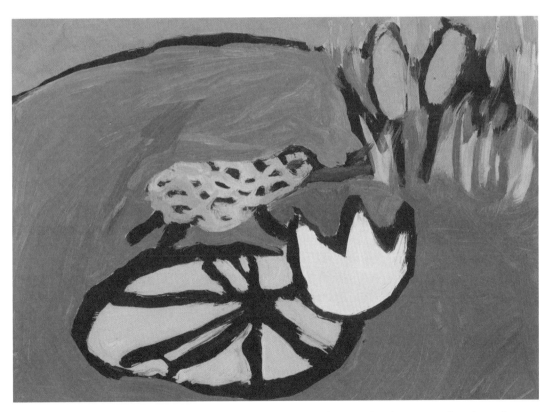

'Bug on a Lily Pad Catching a Fly' painted by Olivia, aged 5, shows tremendous observation and composition skills, especially in the veins on the lily pad and the reeds set off in a section of the pond.

Tufted titmouse, drawn from life during a visit to a nature park, by Olivia, aged 6.

While there are certainly predictable stages that every child will go through, drawing development is a gradual process. Hence, children's developmental levels should merely serve as a guide as to what they are capable of doing. This is because some children may become focused on a certain style of working, preference, theme, subject or medium, for reasons that might only be known to them. Usually they move on; that is, if there is no underlying problem or disorder. But some children need a little more time than others to work out or 'perfect' their drawn symbols in ways that seem right to them. These kids stay right where they are for a while. Children may even go back

and forth between stages. And even children who have already figured out how to represent human figures might want to go back and revisit their scribbling – especially if they wish to express a strong emotion such as anger. Regardless of which stage of artistic development s/he is currently going through, according to Brittain, 'The child's personality often shines through, loud and clear, when he or she draws or paints.'

Inspiration

Inspiration for drawing can come from just about anywhere. One of my most enduring art memories is of the last painting I did in sixth grade (aged twelve). That year I was also a member of the school's choral club, which met in the auditorium for weekly practice. We were rehearsing songs to be sung during the graduation ceremony and had just learned the words to 'America the Beautiful', a poem written by

Crayon drawing of leopards with spotted- and solid-coloured coats by Sebastian B., aged 5.

Katharine Lee Bates in 1893 and set to an older melody written by Samuel Ward in 1882. I was so struck by the descriptive words of the first four lines:

> O beautiful for spacious skies,
> For amber waves of grain,
> For purple mountain majesties
> Above the fruited plain.

Liam, aged 8–9, painted his own illustration for *A Dozen Dinosaurs*, a 1967 book of playful poems about dinosaurs written by Richard Armour.

Julian, aged 9–10, illustrates Boris, the yellow-and-blue striped dragon, in a hole – his favourite part of *The Dragons of Blueland*, the third book in a series by Ruth Stiles Gannett, originally published in 1951.

Those words conjured up vivid images in my mind. While I never actually saw any amber waves of grain in Brooklyn, I did see *The Wizard of Oz* on television and imagined the Scarecrow perched amid the amber fields of Dorothy's home in Kansas. I had once visited an aunt in Tucson, Arizona, and remembered how the sunlight made the sky look all pink, blue and orange, and how the distant mountains looked different shades of lavender. And with these words and images in my mind, I was able to create a painting – no, a masterpiece – of my personal vision of 'America the Beautiful'.

Inspiration also comes from books, which can be read by a parent, teacher, librarian or child. The different styles of illustration in picture

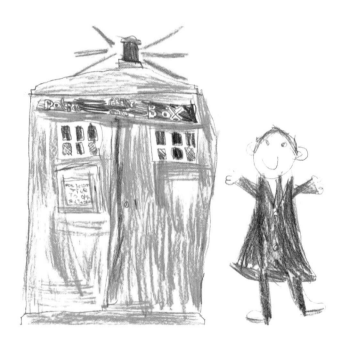

George, aged 7–8, re-imagines his version of the TV series *Doctor Who* and the blue TARDIS. Note how the three-dimensional TARDIS has been 'folded open' and 'flattened' in an attempt to portray two sides.

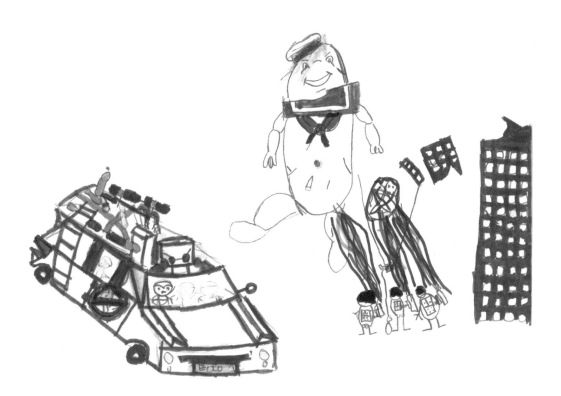

A drawing full of action: the Ghostbusters try to stop the marauding Stay-Puft Marshmallow Man next to a towering building and their well-equipped truck. By George, aged 8.

David, aged 5, emphasizes the distinctive costume that helps define the dual characters of Marvel Comics' fictional superhero Spider-Man and his alter-ego Peter Parker.

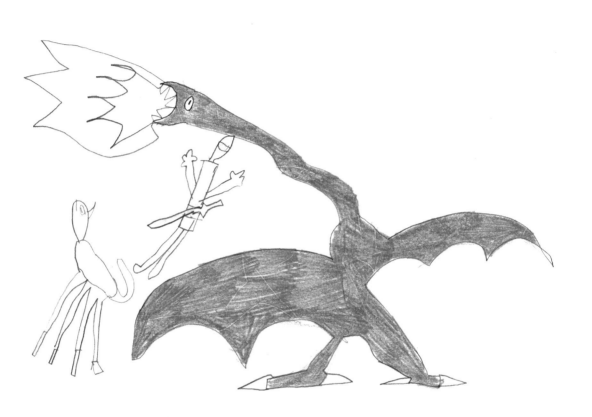

A knight, his horse and a fire-breathing dragon drawn in pencil by Benji, aged 5–6.

books and the stories themselves can provide excellent motivation for children to draw their favourite character or part of their favourite story.

Inspiration can certainly come from films and TV shows as well, especially nowadays, when streaming services make it easy to conjure up a child-friendly film at the drop of a hat. Of course, watching a film on a giant screen or in 3D can be pretty exciting for adults and children alike, and children all over the world often become enamoured of the latest blockbuster. What is important for parents to keep in mind is that the goal shouldn't be for kids to copy movie scenes or characters from adverts in newspapers or magazines, but rather for them to reimagine everything in their minds and then draw their own unique scenarios.

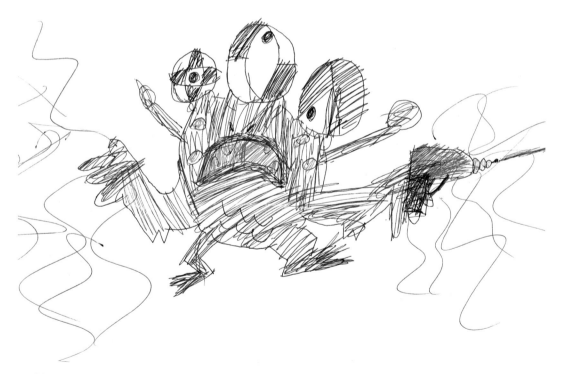

Marker pen drawing of a monster using a fencing foil by Boaz, aged 7.

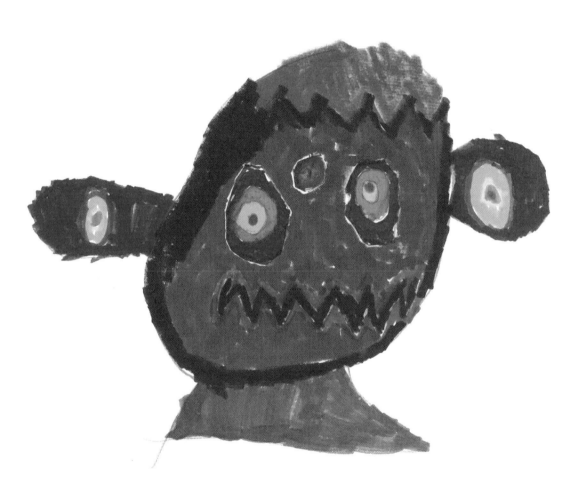

Self-portrait as a monster, by Eddie, aged 10.

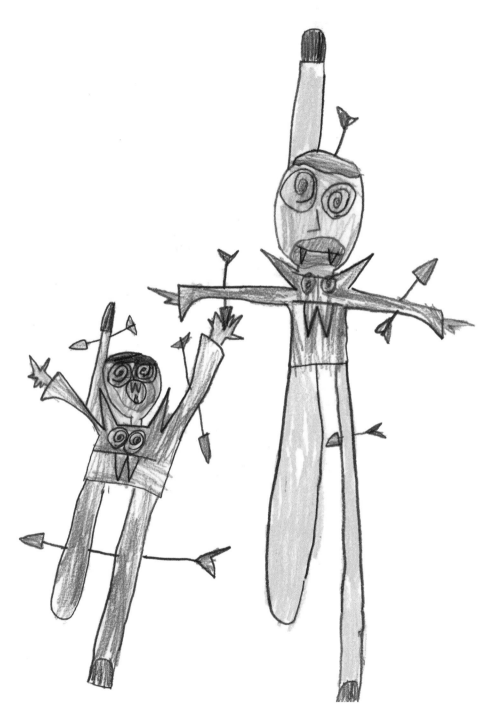

Pencil drawing of fanged and spiral-eyed grown-up and child vampires who have been
pierced by arrows, by Benji, aged 5–6.

Pencil and marker drawing of mutants, by Ayla, aged 6–7.

Menacing monster with outstretched wings, drawn by Charles T., aged 6–7.

Another type of inspiration for drawing involves pure fantasy on the part of the child. Most children love drawing monsters, because they can create the weirdest, goofiest, scariest, craziest, wildest thing that comes out of their imagination and put it down on paper. A number of child psychologists say that drawing monsters is a good way for children to cope with scary feelings and release their anxieties. I have always maintained that every child imagines him/herself as both an angel and a monster, depending on the day, time and situation. And when kids draw monsters, they are usually just having fun.

Disturbing Subject-matter

The psychologist and nursery school director Rhoda Kellogg felt that children follow a predictable course of graphic development, from their first random scribbles to the time when they strive to make images that are 'acceptable' to adults. Kellogg writes in *Analyzing Children's Art* that by the age of four, children begin to draw humans, animals, buildings, landscapes, vegetation, and all sorts of modes of transportation, such as cars, trains, planes and boats. The developmental psychologist Howard Gardner suggests that by the ages of five or six, children have already mastered a basic vocabulary that will enable them to portray the world.

Of course, the way they do this evolves according to the stage of drawing development they currently are in. But soon after that age, some children become increasingly interested in themes of action, power and violence. And they are attracted to films, TV shows, books, comics and anime that present such themes. The content of these is frequently based on archetypal characters representing the polar opposites of good and evil. (Yes, that even includes children's fantasy films like *Frozen*, which was inspired by a Hans Christian Andersen fairy tale.) And while some psychologists suggest that focusing on superheroes can sometimes be empowering for children, many of today's superheroes tend to engage in a high degree of destruction and violence – in the movies, at least. Children draw disturbing things because they see them, hear them or read about them, and although they can't really make sense of a world engaged in non-stop struggles between good and evil, they are exposed to so many images via the Internet, TV and social media that they cannot help but be affected by them.

Unconnected yet related symbols, all drawn realistically by Anna D., aged 9–10.

A Language of Symbols

Two of the earliest human writing systems, Mayan glyphs and Egyptian hieroglyphics, relied on visual symbols – mostly figurative characters that represented words or phrases. Today's children have grown up enhancing their written language with visual symbols called emojis. These are small digital symbols that are used to express ideas or emotions in electronic communications. In some drawings, such as the one opposite, children aim to perfect their drawn symbols – and these may, someday, become a new, yet old, writing or communication system. And why not? Visual symbols have been used throughout time and by almost every culture to communicate meaning.

When?

A flower pot with fluffy blossoms painted by Charlie K., aged 6.

When?

Children's Drawing Development

As children grow, their knowledge expands, their natural abilities flourish and their learned behaviours, or skills, develop more fully. This is true for many 'milestone' activities in a young child's life, including walking, talking and scribbling, a precursor to drawing and writing. As children progress in each endeavour they typically pass through what are usually referred to as the 'normal' stages of development. One caveat, however: stages – and the approximate ages given for each – should be merely viewed as guides, since there is always a broad range of what constitutes 'normal'. Parents must remember that no two children are exactly alike. Children develop naturally when *they* are ready to do so – some more quickly than others. And kids who seem to zoom ahead of the pack in one area might very well take their sweet time in another. There is just so much learning and developing going on at the same time when children are young.

Infants usually take their first steps when they are between nine and twelve months old – around the time of their first birthday. But before they are able to stand and walk on their own, they more

often than not progress through the preliminary stages of sitting up, crawling and standing, each of which represents a new level of skill and achievement. While babies are gaining greater muscle strength, they must also master challenging feats such as balance, coordination and control. And as they continue to explore their surroundings, they quickly learn which furnishings are steady enough to use for pulling themselves up into a standing position and which ones might topple over easily, resulting in a fall. But regardless of how physically proficient a child might seem, it will certainly take a few more years of growth and development before a child can (or should) start training for athlectics events.

Children's verbal skills also go through stages as their vocal mechanisms mature and as they interact more and more with their respective environments. Infants begin making noises such as 'coooh' and 'gaaah' as early as two or three months old and start babbling – that is, experimenting with sounds – as early as four months old. Nowadays, when there are people who post just about every aspect of their lives online, there always seems to be some new video in which a super-cool baby is gurgling and grooving along with his dad's beatbox rhythms. But before children can have anything close to a real conversation – let alone sing background vocals – their cognitive, linguistic and certain fine motor skills used to control the muscles of the tongue and lips need to be ready. In other words, children must not only develop their ability to produce sounds, but they must be able to recognize simple language, make the mental connection between things and what those things are called, and communicate their wants and needs verbally.

Children's drawing development follows a similar course. Very young children will begin making marks and scribbling on paper only when they are ready to do so and when they are interested – provided, of course, that their parents or caregivers supply them with a place to work and some age-appropriate drawing materials. Most parents know

all too well that if an infant is handed a crayon, s/he may hold on to it for a few seconds, look at it, and then promptly drop it on the floor or pop it into his/her mouth. There are some who might suggest that when infants smear food all over their trays they are, in fact, making pre-writing or pre-drawing gestures. Perhaps. But trying to make one's mark when one cannot even control a crayon is really no fun at all. Just as with walking and talking, it is not until babies have developed the coordination, strength and hand skills to the levels necessary for grasping writing or drawing tools – usually around eighteen months of age – that they first become interested in making marks.

As toddlers approach their second birthdays they become better at controlling a writing or drawing implement such as a marker or chunky crayon. Even so, at this point, when children 'draw' they are primarily experiencing how their body movements and arm motions feel, rather than making any sort of connection between their physical gestures and what happens to appear on the paper. Any marks they do make on the page seem to be instinctive rather than deliberate. Soon, however, these kinds of marks evolve into something different: scribbles that appear as though they have been drawn with great conviction and purpose. And while these may look like meaningless lines, loops and squiggles to an adult, they are very meaningful to a young child. These scribbles represent a child's first attempts at written/visual communication: recording or 'writing' down what s/he is actively thinking and feeling about the world around him/her. To put it even more simply, for very young children, their drawings are their writing.

Viktor Lowenfeld believed a child's aesthetic, social, physical, intellectual and emotional growth could be seen in his/her art. In other words, children's drawings not only reflect the child's cognitive development – conscious intellectual activities such as thinking, reasoning or remembering – but offer clues into the child's burgeoning skills (motor, language, perceptual, symbol formation) and awareness

(sensory, spatial, social, environmental, empathetic, cultural and so on). Building upon the earlier works of Cyril Burt and others, Lowenfeld identified and described the general characteristics of six major, continuous and predictable stages of children's artistic development, spanning the approximate ages of two years old through adolescence:

1. Scribbling Stage (2 to 4 years): the beginnings of self-expression, which consists of random, disorganized and, later, clustered marks, lines, scribbles and circular shapes.
2. Preschematic Stage (4 to 7 years): the first representational attempts in which children develop specific ideas and symbols – a visual shorthand, so to speak – to represent people, places and things.
3. Schematic Stage (7 to 9 years): the achievement of a form concept – a specific schema, or image, developed by the child to express something – continues with representational symbols, emphasis on figures, objects, composition and colour, use of a baseline.
4. Gang Age (9 to 12 years): dawning realism, with more natural colours, more rigidity and skill at rendering spatial depth.
5. Pseudo-naturalistic Stage (12 to 14 years): the age of reasoning, with increased awareness of the human figure and the environment, use of caricature and increasing rigidity.
6. Adolescent Art (14 to 17 years): the period of decision in which renderings can be more detailed and sophisticated.

According to Lowenfeld, the changes one sees in an individual child's art reflect the changing ways s/he perceives, represents and functions in the world. However, while the progression from one

stage of artistic expression to another can be readily identified by certain specific characteristics in a child's drawing, knowing exactly why this progress occurs is not so simple. Lowenfeld does note that the gradual movement from one stage to the next seems to coincide with the child's biological and language structure development. Furthermore, he references the noted Swiss psychologist Jean Piaget's study *Judgment and Reasoning in the Child*, citing how Piaget's four stages of intellectual (or cognitive) development – Sensorimotor (birth to age 18–24 months); Preoperational (toddlers aged 18–24 months to early childhood/age seven); Concrete Operational (ages seven to twelve); and Formal Operational (adolescence to adulthood) – closely parallel the developmental stages of children's drawing. In other words, one can assume that a child's growth in art expression is indicative of the development of the child's thinking. In fact, Lowenfeld suggests that, for young children especially, the very activity of drawing is a way of learning and may, in itself, promote growth.

According to the noted author and drawing professor Betty Edwards, the developmental progression in children's art is indeed linked to developmental changes in the brain. She notes that lateralization, whereby specific functions are consolidated into one hemisphere of the brain or the other, happens slowly throughout the early childhood years, corresponding to the development of both language skills and symbols in children's art – around the age of four. In biological psychology (behavioural neuroscience), the brain's left hemisphere is generally believed to control speech, comprehension, arithmetic and writing. The right hemisphere is thought to control creativity and imagination, musical and artistic endeavours, spatial tasks, and body control and awareness. Edwards suggests that, interestingly, lateralization, which is often complete by the age of ten, coincides with a period of conflict in children's artistic expression. At around the age of ten, the left (verbal) hemisphere of the brain becomes dominant and the

use of names and symbols takes precedence over spatial perceptions. This, she feels, interferes with children's ability to 'accurately' draw things in the way they see them, instead drawing symbols to stand for what they know.

For those of us who are repeatedly charmed, amused or amazed by the imaginative art created by children, or for parents and caregivers who simply want to know more about their own children's drawings and how these renderings may fit into their children's development level, Lowenfeld's classic treatise is still considered the seminal work on art education. However, there have been a number of noted, well-respected practitioners and researchers in various fields, including art education, early childhood education, art therapy and cognitive and developmental psychology, who have refined, redefined, expanded, updated, renamed, tweaked or in other ways added new dimensions to Lowenfeld's work.

This might be a good time to mention that, regardless of what the stages of children's artistic development are called, in no way do these stages refer to anyone's aesthetic notions about a child's drawings or their opinions about how beautifully (or realistically) a child might draw for his/her age. To do that would be to look at children's drawings through an adult lens. 'Beautiful' is not what's important, and besides, children draw what they know and what is meaningful to them. What is ultimately important for young children is the process of making the drawing – not the final product – because children are thinking and problem-solving as they draw. And when parents look at their children's drawings, they are getting a glimpse into what is going on inside their heads. Most children will move from one stage into another not because of any prompting or instruction from adults, but because that progression simply represents their development.

Developmental Stages in Children's Artistic Expression

In addition to Lowenfeld's (and Brittain's), other studies have attempted to identify or classify the characteristics of various developmental stages of children's artistic expressions (that is, drawings). While some researchers have assigned these stages different names or slightly different age sequences, there is general agreement on the

An illustration by Joshua, aged 6, depicts a story: 'Bernie Wants to Go Out'. Although the dog is carefully rendered with ears, spots, the correct number of legs and a tail, its limbs and those of the boy are rendered like stick figures, reflecting the child's delayed development.

stages that most young children will typically go through. It should be noted that various factors can affect a child's drawings or progression from one stage of development to the next. Obviously, aside from individual developmental, family or chronic health issues, or child-specific incidents such as repeated peer bullying, there are also numerous external events and circumstances that might profoundly affect a child's drawings. These might include war, famine, migration, natural disasters and more. But that's another book altogether.

For the purposes of this book, I have chosen to borrow the nomenclature of the art therapist Cathy Malchiodi in her book *Understanding Children's Drawings* and title the developmental stages of children's drawings as follows:

1. Scribbling (1.5 to 3+ years)
2. Basic Forms (3+ to 4+ years)
3. Human Forms and Beginning Schema (4–6 years)
4. Development of a Visual Schema (6–9 years)
5. Realism (9–12 years)
6. Adolescence (13–17 years)

Parents should understand that the progression from one stage into another happens very gradually and not overnight. Sometimes it is very difficult to know when one stage ends and another begins. At the risk of sounding like a broken record, I repeat: not all children are exactly alike and some children may even go back and forth or hover between stages for a while. Not all children will, for example, immediately start drawing scribbles that represent human figures as soon as they blow out the 'Happy 4th Birthday' candles on their cakes. Some children will revert to scribbling for a bit even after they have learned to successfully depict a figure. And some children will incorporate drawing characteristics of more than one developmental stage

in their work. Likewise, at a certain age, some children care about using the 'right' colours to depict things in the natural world, while others are perfectly content colouring chartreuse dogs or purple cats. Besides, given the enormous quantity of richly coloured, computer-generated and Photoshopped images children are exposed to daily, who's to say that a pink, polka-dotted pony isn't quite right anyway? Some children use colours that reflect their emotions, while others, perhaps as a way of marking ownership, simply make certain to use every single coloured crayon in the box. (Worthy of mention is a study by A. Corcoran entitled 'Color Usage in Nursery School Painting', published in the journal *Child Development* in 1954. The study reiterated findings from earlier studies which reported that nursery school children painting at easels tended to use each colour following exactly the order in which the colours were placed in the paint tray. And the colour placed on the right was selected first more than 50 per cent of the time.)

Again, as with walking and talking, there is no need to teach young children how to draw, because they will develop their drawing completely on their own. Parents should, however, encourage their children at whatever stage of development they seem to be at and not try to fast-forward them into the next one. These stages are only a guide. As children's bodies and minds mature, so do their drawings. And since children tend to draw what is on their mind, their drawings will change as their interests, needs and abilities change. Just as Pablo Picasso moved from his Blue Period on to his Rose Period when he was ready, children will move into their next stage all on their own. And children who are encouraged to draw both at home and in school simply have more opportunities to practise. Finally, since this book is focused on work done by children aged from two to twelve years old, it will not delve into specifics about drawings done by adolescents. Besides, drawings done during the earlier stages are often the most enigmatic and intriguing – especially to the child's parents.

Stage 1: Scribbling 1.5+ - 3+ years

The Scribbling Stage, sometimes referred to as the 'Manipulative' or 'Organic' stage, was subdivided by Lowenfeld into a number of phases: Disordered Scribbling (alliteratively described by Burt in 1922 as 'purposeless pencillings'); 'Controlled Scribbling' (Burt's 'purposive pencillings'); and 'Named Scribbling'. Parents and caregivers must realize that the younger the child, the fewer his/her emotional outlets and means of expression are. So for very young children especially, scribbling offers happiness, enjoyment, release and the opportunity to use some of their increasingly coordinated physical movements. Hence, for children between one and a half and four years of age, scribbling is usually the primary form of drawing.

The first phase, Disordered Scribbling, begins at approximately 18–24 months of age when, out of the blue, children spontaneously begin making marks on paper (or walls, tables or other inviting surfaces, which might be a patch of dirt in the garden or sand on the beach). This very early phase of scribbling correlates with the latter portion of what Jean Piaget identified as the first phase of a child's cognitive development: the Sensorimotor Stage. During this stage, very young children process information via their sensory perceptions and physical activities. Some call this 'kinaesthetic thinking' and it is a step towards building children's early intelligence and their capacity for future learning.

Toddlers have not fully developed their hand–eye coordination and small muscle control. So while they can grasp a crayon (or pencil, felt-tip pen or stick, for that matter), they usually do so by making a fist using the whole hand. It is difficult for them to place their drawing marks exactly where they want to because they have practically no wrist or finger control at this point. Instead, these very early scribbles are actually made by the child moving from the shoulders and by swinging his/her whole arm rhythmically, often repeatedly, in large gestures.

Scrubbing-like crayon scribbles by Jamal, aged 2 years 4 months.

In fact, the scribbles look – and very well may be – entirely random, chaotic, disordered and accidental, as the child may or may not even look at what s/he is doing during the process. Instead, toddlers are primarily focused on their own motor activity and the physical enjoy- ment they feel while making these large muscle movements. And it is a tremendously enjoyable activity for them. Most of the time they don't even stop to lift the crayon off the surface, making the scribble one continuous, albeit inconsistent, line. Although a circular movement is probably the most natural movement, sometimes they make repetitive back and forth movements that appear as though they're scrubbing a kitchen counter. Watching children draw during this early phase can feel a bit creepy for parents, especially as the child's repetitive, swaying arm movements may seem almost zombie-like, and if his/her eyes

Disordered, rhythmic scribbling by Sybil, aged 2.

look like they are staring somewhere off into space. However, don't be fooled into thinking you can trick a toddler by handing him/her a dried-out old marker or one with the cap still left on. If the drawing tool stops making marks – for example, if the pencil point breaks off – most children will lose interest in the activity pretty quickly. Regardless, as a pleasurable sensorimotor activity, scribbling also helps to promote a child's healthy physical development.

During this early phase, children will certainly use a piece of paper if it is provided, but they pay little heed to its borders, frequently

scribbling beyond the edge of page. This is because the size of the scribbles has less to do with the size of the paper surface than it does with the range of motion the child can make with their arms. For this reason alone, parents might want to rethink offering their child standard-size office copier paper and instead invest in an inexpensive, larger-size newsprint pad or a ream of Manila drawing paper. Children in this phase also seem perfectly content to ignore any previous marks on the paper, whether or not those marks were made by them. This will soon become crystal-clear to any well-meaning parents or caregivers who purchase simple colouring books for their children, only to have their kids scribble all over the black outlines of cutesy animals and princesses pre-printed on the page. The same goes for those activity sheets that double as paper placemats in some fast-food establishments. All children, regardless of where in the world they live, start with this type of scribbling activity at this age, before any specific cultural influences affect their artistic expressions. Needless to say, depending on the child's living environment there may be variations in what s/he draws and the types of drawing materials s/he uses. But all children will scribble until about the age of four. For two-year-olds, scribbling becomes an important means of expression. It is like a written language of marks made by the child's gestures. Parents need only provide the materials and opportunities for them to grow.

After about six months or so of Disordered Scribbling, children move on to the second phase of Scribbling, called Controlled Scribbling. This stage begins with that 'Aha' moment when a child suddenly recognizes that there is a relationship between the movements of their arm and the marks s/he makes on the paper. Now children start becoming much more interested in what they are doing, even looking at their scribbles as they work. And while they still have limited attention spans and motor skills, they like to spend more time drawing, experimenting with different lines and colours.

Transitional drawing of disordered scribbles with elongated dots by Kyrie, aged 2.

Linear scribbles that resemble writing, by Gwyn, aged 2–3.

Once children discover the connection between their physical motions and the visual images that appear on the page, they become highly motivated to vary their movements so as to produce different types of marks, such as circles, loops, lines and swirls, which are considered by many to be pre-figural (and pre-writing). Children's motions gradually become more refined and deliberate. Wrist movements begin to dominate over arm movements. Then finger movements dominate over wrist movements. With more hand control, their marks become smaller and can now be repeated. Howard Gardner notes that better coordination and control also means children can now lift a crayon on and off the paper more easily, often resulting in scribbles with sprinklings or clusters of dots. He also suggests that certain scribbles might be akin to writing forms, in that they resemble adult-like signatures.

Burt also alluded to this phenomenon back in 1922, suggesting that the movements made by a child scribbling looked like the movements of an 'adult draughtsman'. But while these marks and movements might seem reminiscent of adult writing and drawing, the emphasis still tends to be muscular rather than visual or intellectual.

Meanwhile, some children will still be figuring out how to form an adult grip on their drawing tool and may compensate by pressing down really hard. This is especially true if they are using a medium with a softer consistency – like a paint stick or gel crayon – which allows them to achieve darker, denser colours when more pressure is applied.

Classic multiple-line overlaid circle – one of Kellogg's 20 Basic Scribbles – by Sarabeth, aged 3.

Gel crayon drawing with different types of lines and marks by Sybil, aged 2 years 7 months. Drawing at an upright easel on larger paper offers children a different perspective and enables them to use broader arm gestures.

Gel crayon drawing with classic zigzag lines – one of Kellogg's 20 Basic Scribbles – by Sybil, aged 2 years 9 months.

From 1948 to 1966, Rhoda Kellogg collected and analysed thousands of children's marks and scribbles. In her 1967 book *The Psychology of Children's Art*, written with author Scott O'Dell, Kellogg identified twenty basic scribble shapes that children use in their earliest renderings. These basic scribbles include specific variations of dots, single lines, multiple lines, zigzag lines, loops, spirals and more, eventually evolving into a full alphabet of scribbles. And while these twenty basic scribble shapes appear to be universal to all children, an individual child won't use them all, instead repeating his/her own personal preferences.

According to the psychologist Maureen Cox in *Children's Drawings*, children may also engage in a type of pretend play with their drawings.

Cox suggests that the physical gesture of moving the crayon or marker on the page might be depicting some sort of familiar action or element in the child's environment. Thus an energetically drawn line may represent a pet animal scampering across the page, or a group of dots may represent bursting soap bubbles, snowflakes, raindrops or falling autumn leaves. After a scribble is finished, adults might be tempted to suggest that a shape that was drawn might resemble something in the real world, such as the silhouette of a leaf. However, even if the child recognizes and acknowledges the shape as a leaf, there is no way

Pre-figural form with clustered dots by Olivia, aged 2.

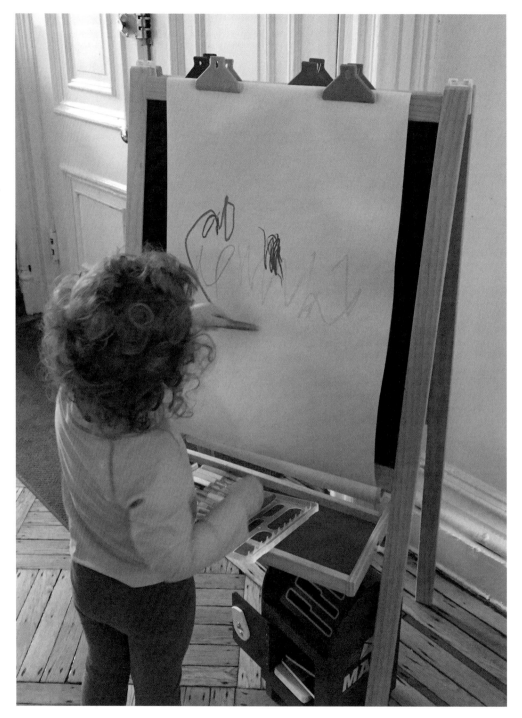

Sybil, aged 3, draws at her easel.

of knowing if drawing a leaf was the child's original intent, or simply his/her reinterpretation upon second glance. In fact, children might identify their scribbles as one thing at first but then change their minds about them during the process of drawing or even later on.

During the Controlled Scribbling phase, children tend to stay within the boundaries of the paper or drawing area – or at least they seem to try. They may or may not use certain colours and spend more time on certain parts of their drawing rather than others, indicating personal preferences for placement and arrangement. And they are usually careful to avoid scribbling over any marks that were previously made on the page. Being allowed to draw freely, with the power to choose colours and exercise other individual preferences, contributes to the child's growing sense of autonomy, which is important to his/her emotional growth.

Stage 2: Basic Forms *3+ – 4+ Years*

The last phase of Scribbling is transitional and typically occurs when the child is between three and four years old. Lowenfeld called this phase Named Scribbling, and believed it signified a change in the child from kinaesthetic 'thinking' to imaginative thinking. Moreover, he suggested that this stage marked the first conscious creation of form and that it began a tangible record of a child's thinking process. Others, including Malchiodi, have categorized this as a separate and distinct second stage of drawing development called 'Basic Forms', which usually includes the naming of scribbles. She suggests it roughly coincides with the early part of Piaget's 'Preoperational' phase of cognitive development in which the child, now considered quite egocentric, is learning to use the symbols of language (words and images) to refer to objects. With the beginnings of symbolic thought, children can start to classify their environment using line, form, size and colour.

David, aged 3–4, paints intently at his easel.

However, since youngsters are continually developing and focusing on new concepts, their symbols are frequently changing.

At this point children have longer attention spans and will relate their marks on the paper to things that they know, such as a flower or tree. They might even point something out to an adult as a person or thing, or name an action, such as running or jumping. Children can now also hold the drawing implement between their fingers, affording

them more control and enabling them to place marks exactly where they want. They can also make different types of lines. Eventually, the ends of lines connect, becoming shapes. And even an empty space on the page can take on specific meaning.

In *Young at Art*, the elementary art educator Susan Striker suggests that, besides offering the child an emotional outlet, a child's scribblings may also reflect his/her personality and even the way s/he approaches the world. A number of children of the same age, at the same stage of development and given the same materials will each create very different images. An outgoing, sociable child will tend to create bold, dramatic-looking scribbles, while a child who is more apprehensive or lacks self-confidence will tend to produce more timid scribbles.

Notably, in *Artful Scribbles*, Gardner identifies two types of scribble makers in the Basic Forms stage: children who are 'patterners' – those interested in patterns, colours and shapes – and children he calls 'dramatists', those interested in action, adventure and dramatic stories. 'Patterners' like to explore and experiment but are not necessarily interested in social interaction. 'Dramatists', on the other hand, enjoy pretending and storytelling and relish interaction with other children and adults. Figuring out which type of scribbler one's child is may offer parents clues as to whether or not a child enjoys talking about (or during) his/her drawing. Some kids just want to be left on their own to mix colours and shapes or see what happens when they combine different materials. And some children are neither 'patterners' nor 'dramatists', while others are a little bit of both.

Gardner also writes about the 'romance' some parents seem to have with encouraging children to name or explain their images. Often, there is no simple description a child can use for his/her scribbles. In fact, children often make up stories about their drawings that they think will please their parents. There is evidence to suggest that when

Multicolour gel crayon drawing with distinct pattern and circular placement preference by Sybil, aged 3. Evidence of one child's growth and development can be clearly seen by comparing her drawings made at the ages of 2 (p. 70), 2 years 7 months (p. 75), 2 years 9 months (p. 76) and 3 (above).

Sebastian S. W., aged 3–4, depicts 'Snowball Fight Going Downhill with My Dad' in watercolours over black marker.

'Rocket Ship Voyage', a dramatic portrayal painted in tempera by Charlie K., aged 3, focuses on the fire and smoke at the moment of the ship's take-off.

children name their scribbles, they are making connections between their drawings and the world around them. That may be true. But Striker notes that shapes often look similar to one another and that shapes can represent a number of objects. So the name a child gives a scribble or the story s/he uses to describe it may change each time it is viewed. Nonetheless, writing and attaching a story to a child's drawing seems to be a fairly common practice in preschools and nursery schools, with the drawings children carry home then also serving to inform their parents of what they did in school that day. Striker discourages parents from writing anything on their children's drawings, because she believes it intrudes on their work. Similarly, she discourages parents from recording any title or story on the drawing itself, because it can prevent the child from discovering new things about it each time s/he goes back to look at it in the future.

Trains are obviously of great interest to Daniel, aged 3–4, who has drawn the train's big steel wheels and other mechanical workings underneath the long windowed car with smoke rising up.

Train tracks, also drawn by Daniel, aged 3–4, show his careful attention to pattern.

An enclosed mandala-like drawing with crossed lines by Shane, aged 3–4, has been partially obscured by energetic over-scribbling.

Last, it should be noted that in the numerous drawings made by children during this stage, Kellogg, Striker and others identified more complex forms which they describe as 'mandalas', the Sanskrit word for circle. According to Kellogg, the mandalas children draw are usually emblem-like configurations made up of a circle, square or rectangle with lines crossed over them. They can take many different forms and may be deeply embedded within a larger drawing, making them difficult to spot. While it has been suggested that children are ready to draw rudimentary figures soon after drawing mandalas, not all children create the latter.

Stage 3: Human Forms and Beginning Schemata 4-6 years

One of the most important points in the development of children's drawing is reached when children discover they can now transform a line into an enclosed shape. That first enclosed shape, usually a circle, has been described as the child's preliminary attempt at making a realistic drawing. The circle, according to Edwards, is a universal symbol that can represent just about anything. To Piaget the accomplishment also indicates increased symbolic thought. Lowenfeld and Brittain identified this stage as Preschematic, or the child's first conscious representational attempts. Edwards calls this the 'stage of symbols'. And in *Art, Mind and Brain* Gardner referred to this stage as the beginning of 'the golden age of drawing'.

An important characteristic of this developmental stage is the way children conceptualize and represent space in their drawings. Malchiodi writes that children are primarily thinking of the space in relationship to themselves and their own bodies and, as yet, have no conception of spatial relationships beyond that.

Essentially, at the beginning of this stage there is no conscious attempt at design or composition. There is no baseline representing the ground, and in fact children sometimes turn or rotate the paper

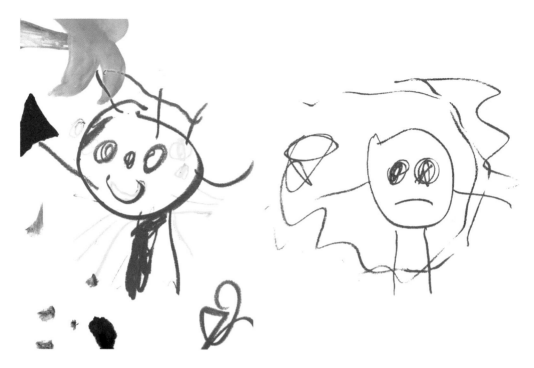

Two drawings of tadpole figures by Sarabeth, aged 3–4, of a happy (left) and not so happy (right) person. The downturned mouth may indicate precociousness, or just an angry or unhappy moment.

Part scribble, part flying tadpole person drawn in Cray-Pas (oil pastels) by Shane, aged 3–4.

while they are drawing. Objects are drawn so that they fit into the given space and seem to float randomly around the page. The sizes of different elements are distorted and they are not necessarily in proportion to one another. In fact, the people and things that are portrayed in the same drawing may not even be conceptually related to one another. (It might be like having Peppa Pig and Shaun the Sheep together in the same animated cartoon.) It almost seems as though each individual child may have worked out his/her personal visual rationale with an eye towards an economy of lines and shapes.

By the age of three and a half, children's drawings reflect their growing awareness of the world. More often than not, the subject of that first realistic drawing is an odd-looking human figure that psychologists and educators almost universally refer to as a tadpole or a tadpole person. This is usually rendered as one circular shape for the head, with two vertical lines for legs and, sometimes, circles, dots and a few lines are added to indicate facial features. Sometimes, the person is represented by little more than the head, which is often smiling.

Tadpole people can 'float' alone somewhere on the page, or they might be joined by other scribbled elements to depict a particular action, event or story. To the child, this tadpole figure can represent any and every person. (I have never seen or heard any reference to these types of figures as something other than 'tadpoles' or some variation thereof. To me, however, they have always looked more like squishy boiled eggs with twigs or toothpicks stuck into them, or Egg Men.)

For children, the tadpole person is a flexible symbol that is constantly changing. The circle may represent just a person's head or it may represent an all-in-one head-plus-body blob – sometimes with an added dot for the navel set in the middle of the blob. Gradually, children add lines for arms, often originating directly from the head, especially when they are needed to represent a specific action or activity such as kicking a ball or holding a balloon. Then come fingers and

toes. Elements such as hair, clothing and other details are generally seen later on in this stage.

Interestingly, according to Cox and others, while it may not always be evident in their drawings, even at the beginning of this stage children are usually aware of different body parts and how they fit together. While children may not yet be at the stage of drawing human figures comprised of geometric shapes, studies have shown that they can correctly 'build' the head, torso and extremities of a person's body

'Me and My Brother Sam in Sun Valley with Stars, a Pond and a Bridge' by Oliver, aged 4. The figure of the child takes centre stage with his brother on the upper right-hand side walking on the bridge, the pond on the lower left and dots representing the stars. Everything seems to float around the page.

'Person and Tree' by Sebastian S. W., aged 3–4. Much attention has been given to the leaves on the tree.

'Me in the Winter with a Really BIG Snowball My Dad Made for Me'. A marker drawing by Sebastian S. W., aged 3–4, in which the snowball is portrayed larger than the figure.

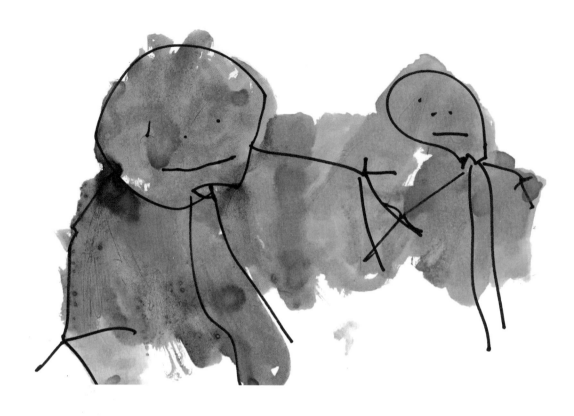

'My baby is here . . . he came in the winter', by Sebastian S. W., aged 3–4, celebrates a big
event in his family life: the birth of a baby brother. Sebastian distinguishes himself not only
by size but by using a variety of different colour washes over the black marker drawing.

An elegant drawing of a person holding a balloon, by Daniel, aged 4, carefully portrays the long string connecting the figure's hand and the balloon floating in the sky.

This marker drawing of two figures walking on a sunny day, by Willa, aged 3–4, fills the page and emphasizes the hair and eyelashes. The continuous jagged line on the left may represent the path taken by the walkers.

using three-dimensional blocks or tiles. Moreover, they are perfectly amenable to adding a body part to their drawing if someone reminds them it's missing. Hence, tadpole people may just be a quick and easy shortcut for younger children to convey the idea of a human figure. This alone is a good reason why parents and caregivers should encourage children to talk about their human figure drawings. When given the opportunity, the child may surprise parents by pointing out details that are not readily apparent to anyone but the child him/herself.

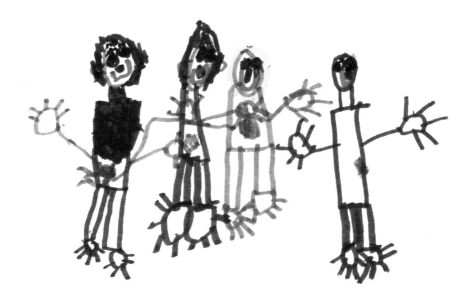

Drawing of his family members by Nicholas, aged 5, who was careful to give each person five fingers and five toes. The figure of the mother, the only female and the only family member with blond hair, is drawn in grey marker pen, while the others are drawn in brown.

As children progress through this stage of drawing development, they will continue to draw their figures over and over again, refining them, adding more details, making them more expressive and eventually distinguishing them from one another. By the age of four, some children can draw figures by stacking geometric shapes beneath a head, and they become very aware of clothing details such as buttons, shoelaces and zips. Drawings that depict arms and legs with volume, rather than as single lines, don't usually happen until the ages of five or six. Towards the end of this stage, most children will include many more features, such as hair, ears, eyebrows, teeth, fingers and toes.

One genre that seems to have great appeal to children during this stage of their artistic development is the portrait, both of themselves (self-portraits) and of others, frequently family members. Whether the idea for such head shots originates with a parent or art teacher,

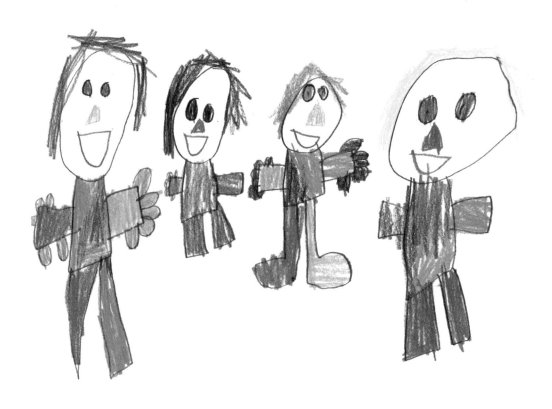

Drawing of the family by Nicholas's twin brother, Sebastian B., aged 6. Sebastian is the
only one drawn with shoes and only he and his father have been drawn with fingers.

Hailey, aged 7, depicts a girl using simplified shapes for the head and body, linear limbs and the same circular forms for both the hands and feet. The importance of the hair is shown by using a special colour.

Marker pen drawings by Jane, aged 5–6. According to the child, the figure above depicts either a flying person, a fairy or 'cousin Doug' and has a two-tiered costume, arms and wings, and extra-special hair or a halo. The figure opposite has a human body 'built' by stacking a face and geometric shapes together.

Micaela, aged 5–6, draws 'A Fun Day in the Park with Mami and Papi'. The smiling faces, outstretched arms of the parents, sunny day and butterflies all contribute to a happy story. The originality and attention paid to the parents' clothing, shoes, hair and jewellery indicates how proud the child is of her stylish parents. Also, the parents and the child on the swing are drawn in elevation view while, simultaneously, the bicycle is represented using a bird's-eye view.

or if they are inspired by mobile phone selfies, they have long been popular drawing subjects. Notice how, in the self-portraits here (pp. 101–5), each child presents him/herself in a way that focuses on what s/he feels is important or distinctive. Some headshot-type portraits of children's mothers tend to emphasize what might be recognized as more 'feminine' characteristics, such as hair, eyelashes and lips (see p. 106 top). (I should add that while most dads have hair, eyelashes and lips as well, these 'feminine' features are often the same as those frequently seen in adverts for make-up and hair products that are targeted at women.) Other drawings of 'Mum' may emphasize an important activity such as her work, especially if the child's mother works from a home office or studio (see p. 106 bottom).

Children at this pictorial stage also begin to develop symbolic landscapes (see pp. 90–91, 107–8), often including houses and common

Self-portrait with curly hair drawn in chalk on a blackboard by An, aged 4.

Crayon self-portraits by Nicholas (above) and Sebastian B. (opposite), twin brothers aged 4–5, in which the rendering of the hair and clothing highlights their differences.

This smiling self-portrait drawn in marker pen shows Isabel, aged 5–6, with rosy cheeks, freckles and glasses and surrounded by clouds, bugs, toys and games.

This self-portrait with thought bubbles and raised arms by Micaela, aged 4–5, depicts a 'Eureka' moment.

While some facial details are either absent or painted over, both the background colours and the facial expression are happy in this painted self-portrait by Charlie K., aged 6.

Left: 'Floating head' portrait of 'Mum' by Talia, aged 5.
Right: 'Floating head' portrait of 'Mommy' by Nicholas, aged 5–6. Note the attention given to 'feminine' characteristics such as the hair, long eyelashes and red lips in both drawings.

Two-part pencil drawing of 'Mom as a Videographer' and 'Mom Editing' by Julian, aged 5–6.

elements in the environment, such as trees, flowers and the sun. Houses and buildings are usually drawn using symbolic shapes rather than by directly observing a specific structure. Trees may be drawn like early depictions of humans in that they have one form for the trunk and a few spindly branches sticking out of it. And elements often float on the page without any drawn baseline or skyline.

At four to five years old, some children begin to draw pictures that tell stories – some subtle, some not so much (see pp. 91–4, 109–10). Drawing these stories can help children work out their problems or

Symbolic landscape with a house, flowers and animals, by Anna B., aged 3–4.

express their feelings about something. Once a problem or issue is expressed visually, a child (or adult) often feels better able to cope with it. In other circumstances, children may use their drawings to project their own feelings about an external event, situation or something they saw that made them think about the way they might feel under similar circumstances.

At this stage children do not need much motivation or encouragement to draw. But the more they relate to what they are drawing, the more meaningful it will be for them. Lowenfeld suggests that

Landscape of a city park by Manny, aged 5, with spindly trees, clouds, a rainbow and what appears to be either an obelisk or a tall building in the background.

An emotionally sensitive and perceptive drawing by Max, aged 5–6, illustrating an Olympic Games awards ceremony with the three athletes who won first place (gold), second place (silver) and third place (bronze). Notice the unhappy facial expression of the athlete who stands on the third-place podium, undoubtedly disappointed because they didn't win the gold medal.

'Moving Day', an emotional event, is portrayed by Julian, aged 7. This drawing depicts Julian and his mother inside the rented U-Haul moving van that will carry all of their possessions to a new home in a different US state.

the best motivation might be for parents to ask children to recall something they were personally involved in, such as a trip to school or the park, or attendance at a birthday party, and encourage them by asking probing questions that address the 'who', 'how', 'what', 'where' and 'when' of the situation: when did you go to school? How did you get there? Did you ride on a bus? What did you see on your way to the park? Who did you play with there? What did you see at the birthday party? Did you eat anything special there? Since children in this stage are particularly interested in representing people and have a growing awareness of body parts, other subject-matter might address situations that are child-specific, such as 'I am brushing my teeth', or 'I fell and hurt my knee', or 'I went to visit Grandma and Grandpa' (or

4-6 years

whatever other endearing names your family uses for grandparents). If an event occurs that is particularly important to the child, such as 'My cat had kittens', 'I got new shoes' or 'I went to the doctor', then the child should be encouraged to record his/her experience and express his/her feelings about it.

Stage 4: Development of a Visual Schema 6-9 years

Children progress quickly in their artistic abilities during this stage, during which, according to Lowenfeld and others, they develop a personal 'form concept' – visual symbols, or specific schemata, for just about everything in their environment, including people, animals, trees, houses, furniture, flowers, objects and the overall landscape. Not surprisingly, drawings created at this time represent the child's active knowledge of the world around him/her. It is a time when, according to Piaget, children are just beginning to be able to organize their thoughts conceptually and are looking for order, structure and some 'rules' for behaviours in their lives and in their surroundings. A combination of sameness and repetition reassures children and affords them a sense of control over things. Hence some children develop quirky little rituals and insist that these be part of their daily routines, such as wearing the same hat each day, demanding a certain plate or spoon at mealtimes or touching each postbox they pass on their walk to school. These rituals, along with daily routines such as requiring bedtime stories be read each night in a specific order, help children feel more secure about who they are and their place in the world. This quest for sameness and order carries over into their art expressions as well: children at this stage of drawing development tend to symbolize their environment and elements within it. They also repeat the same symbols over and over again in their work, usually to portray houses, trees, flowers, rainbows and more. These symbols, or schemata, are

only modified when the child wants to convey some special action or meaning.

Malchioldi and others note that many of the symbols used by children at this stage of development are fairly standard, such as boxy houses with squarish windows and pointy roofs, trees with brown trunks and puffy green tops, flowers with lollipop or zigzag tulip tops, rainbows and, of course, the ubiquitous yellow sun with rays extending outwards.

In her popular instructional book *Drawing on the Right Side of the Brain*, Edwards encourages adults to first recall, then later draw, the landscapes they might have drawn as children. She suggests that, regardless of where one lived, adults usually recall a landscape they might have drawn as five- or six-year-olds, complete with an indication for the ground, the sky, a sun and a symbolic representation of a house. That is, a rectangular box with a triangular roof and square windows, perhaps with curtains, maybe a fence or a chimney with smoke streaming out of it, a few birds, pointy mountains, or a little pathway leading to the door, and *always* a door with a doorknob. In fact, Edwards says she has never seen any authentic child's drawing of a house without a doorknob, because 'that's how you get in.' (In fact, even representations of other types of dwellings , whether they be multi-unit apartment blocks, medieval castles or farmhouses, usually have doorknobs.) The manner in which these symbols are drawn is always simple, bold and direct. It also looks as though everything in the composition is placed almost perfectly and distributed throughout the paper. Moreover, Edwards notes that children feel a deep sense of satisfaction as they draw each element in what they deem its 'right' place. And they derive a great deal of pleasure when they are convinced that their drawing is complete, with absolutely nothing left out.

And as the average six-year-old still cannot represent depth, most things are drawn flat with very few elements overlapping. A blue

In this drawing by Leila, aged 3–4, showing a house floating between the sky and the ground above a row of lollipop-type flowers, hearts symbolize a happy environment. Note the heart in the centre of the house surrounded by four symmetrically placed windows and the little door with a doorknob so it can be entered.

Cecily, aged 5, has drawn a landscape with a row of flowers growing out of the ground and happy shapes such as stars, hearts and flowers floating above them, under the sky.

Nicholas, aged 6, depicts himself playing football (soccer) on the ground under the sun and sky. The arms and legs show volume and are correctly placed, with particular attention paid to the one leg kicking the ball across a long (empty) distance.

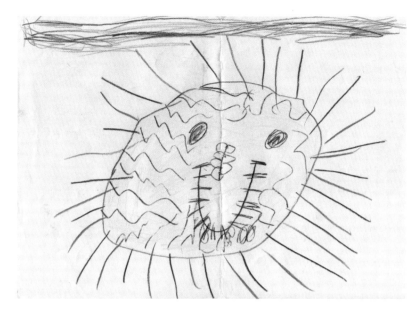

A hot, smiling sun with rays emanating from it is drawn in the 'air space' under the line representing the sky. By Talia, aged 5–6.

line at the top of the drawing and a green line at the bottom become symbolic representations of the sky and the ground. Everything in between usually represents the air. And almost everything children draw is placed on a baseline that is either the bottom of the page or the green line representing the ground. But sometimes, depicting a particularly significant experience might require the child to deviate from this typical schema.

Lowenfeld identified a number of these 'subjective space representations'. Sometimes things that are meant to be standing up are drawn in a way that makes them look as though they are tipped over, lying down or even upside down – a concept Lowenfeld termed 'folding over'. Sometimes, instead of using a baseline as the ground, children will arrange people in a circle, such as seated around a dinner table, where a variety of viewpoints are shown. Some children will attempt to show three dimensions by drawing a table with all four

Painting by Mary, aged 6, done in art class with an art teacher, depicting the 'triple-decker' houses in her New England neighbourhood, each with symbolic roofs, chimneys, windows, doors and doorknobs.

Even this unfinished, yet original, drawing of a tall New York City apartment building by Manny, aged 5, has the requisite windows, door and doorknob.

'Me Playing Lacrosse' by Julian, aged 6. The playing field and goaltenders are shown in plan view (from above) while the midfielder is shown in elevation view.

legs or a car with all four wheels showing at the same time. Others may portray specific people or objects in plan view (from the top down) while other elements in the same drawing are shown from the side in elevation view. As children move forward in this stage, they might attempt to represent perspective by drawing two baselines, or try showing objects in the distance by placing them higher up on the page. Some children will make 'X-ray' drawings showing the outside and inside of something at the same time. They might also depict something happening over time, such as a figure with one leg extended to kick a ball and the ball flying through the air. And they might also exaggerate the size or shape of something in their drawing to emphasize its importance.

Children usually have their own ideas about what to draw at this stage in their development. But Lowenfeld and Brittain also suggest

'When I Grow Up I Want to Live in a House with a Chinese Restaurant In It' – a drawing by Julian, aged 6, complete with a path leading to the garage, a car with all four wheels showing, and a symbolic house, door and the proverbial doorknob. Note the attempt to show distance by having multiple groundlines and to indicate perspective by drawing the more distant garage higher on the page.

offering topics that focus on active experiences, which will discourage the use of stereotypes and at the same time may encourage a flexible use of schema. In other words, starting with the 'I' or 'we', then adding some sort of action, followed by the 'where', should cover all the essentials. 'We are going ice skating on the pond', 'We are bicycling in the park' or 'I am shopping at the hardware store with my dad' are just a few examples. Topics such as 'I am playing *Super Mario Odyssey* on the sofa with my friends' or 'The whole family came to our house on New Year's Day' may help encourage the use of three dimensions. To help children develop flexible representations of time and space, parents might want to first discuss an experience that involves multiple

An 'X-ray drawing' by David, aged 5, showing both the outside and some of the inside of a fire engine.

aspects, such as 'We baked cookies and then ate them', 'We watched a parade' or 'Our trip to the Science Museum'. To help the child develop a flexible use of colour, they suggest topics that include active experiences yet also promote colour awareness. These might include 'We are raking autumn leaves in the yard', 'I have new fish in my aquarium' or 'I like mustard and ketchup on my hamburger'. Topics such as 'We took our dog to the vet' or 'Moving to our new home' may help promote flexible understanding of an emotional experience. Last, they also note that other topic areas to consider are ones that may have deep emotional significance for the child, such as dreams and fantasies: 'I once had a scary dream', 'If I were the richest person in the world', 'I am pretending to be a wild animal' and 'If I could do anything I wanted for a day' are some suggestions. Subjects such as these offer children a positive way to express intense feelings and emotions in

their work. However, parents and caregivers must remember never to voice any moral judgements about the content rendered in these types of drawings.

Stage 5: Realism 9 -12 years

Youngsters at this age tend to assert more social independence from adults and learn about social interactions and social structures in a more personal, individualized way. But while they may be more

Because of their importance, Olivia, aged 6, has drawn the red flower and hummingbird eating nectar from it in the foreground much larger and out of proportion with the tree, bird and nest behind them.

Outdoor chalk drawing of a happy, cool-looking girl with chunky heeled shoes.

independent of adults, they are more eager to conform to their peers. According to Malchioldi, this is an age when youngsters move further away from egocentric thinking and start to consider the thoughts, feelings and opinions of others. They are now beginning to understand interrelationships and interdependence with others, which in turn helps them learn how to interact and work in groups. However, children also begin to compare their drawings with those of others and become much more critical of their own efforts. They are also becoming increasingly aware of their physical environment. Hence the symbols and rigid schemata that they relied upon before and which

were so useful in the earlier stage of drawing development no longer seem to work. Instead, there is a very strong desire to depict things as realistically as possible.

While Lowenfeld called this stage the Gang Age, Edwards subdivides this stage into two parts. The first, which she calls the Stage of Complexity, starts around ages nine to ten. This leads into the second part, the Stage of Realism, which begins around ages ten to eleven. The first part of this stage is when children first try to incorporate more detail into their work, presumably to achieve what they now feel is the ultimate goal in their drawing efforts: greater realism. Previous concerns about where things were placed in the composition are superseded by more pressing concerns about how things look.

There is an awareness of the interrelationship between objects, which may now overlap, or may be drawn smaller to indicate they are further away. In fact, transparency – things seen in glass vases, under water or through glass windows – becomes a popular theme, basically because some children want to try to see if they can make things 'look right'. Some youngsters try their hand at perspective or foreshortening, or attempt to represent things from a more 'professional' or adult point of view. The 'fold-over' depictions seen in earlier drawings are replaced by attempts to show depth and three-dimensional space. Usually, the baseline that was previously seen at the bottom of the page is now completely gone, and the sky is drawn or painted so that it comes right down to the horizon line. And there is now more awareness of accurate depictions of colour. What was formerly a green sweater is now described and shown as more of a bluish-green, a yellowish-green, a dark green or a light green colour. Nonetheless, while the drawings youngsters create at this stage move closer to reality in colour and form, they are still a far cry from accurate visual representations. Lowenfeld suggests that this is because most of their drawings are not the result of careful observation but instead are a characterization

While the vase may not be completely transparent, at least one part of it is, on the left side. This marker and pencil drawing by Anna B., aged 10, also depicts the vase's shadow.

'Designing an Ideal Garden for Our New House', boldly drawn mostly in aerial (bird's-eye) view by Julian, aged 9–10. The trees and birdbath are shown in elevation.

of what is seen. And while the drawings may show more details, they may also seem to be more stiff and to show less spontaneous action.

The drawn concept of the human figure now moves from a generalized person to one that shows greater detail, especially with hair, physique, clothing and other gender-specific characteristics. Also around this time, children's drawings become differentiated by gender, probably because of cultural factors. On the one hand, boys – at least those in Western cultures – traditionally draw all sorts of cars, from racing cars to fantasy cars; battle and outer space scenes; rockets and sci-fi weapons; bearded pirates; Vikings; legendary heroes and

VW Beetle car drawn from direct observation by Patricio, aged 9.

superheroes; TV, film, comic and sports stars; dinosaurs, monsters and more. Girls, on the other hand, tend to draw what are typically considered 'gentler' things, such as flowers in vases, pretty landscapes, horses, unicorns, and fashion models or pop stars with amazing hairstyles and eyelashes, streamlined waists and tiny feet. However, now that more TV, comic, film and pop stars have showcased girls and women in the empowering roles of heroes and superheroes, the subjects of some girls' drawings are beginning to overlap with those of boys.

While adolescents are obsessed with body image and appearance, pre-adolescents carefully study faces. No longer content to draw human faces and figures the way they did before, they now want to draw them with more perception and detail. Faces and figures are favourite subjects to draw at this age, but they are also the biggest challenge. Pre-adolescents can spend a good deal of time trying to draw hair and clothing in just the right way. Some try using photos, especially when attempting to draw portraits of themselves or their friends. Unfortunately, working from these photographic images often undermines a youngster's newly acquired observation skills. And some youngsters get so frustrated that they set aside their drawing

An original monster drawn and painted by Eddie, aged 10.

This notebook drawing of an imaginary 'Fast Car' by Charles T., aged 6–7, shows advanced skills.

Fashion drawings showing 'models' (above) and 'girlfriends' (opposite) with chic clothing and elongated figures, by Astrid, aged 10. Note that one of the friends (second from right) was started but crossed out, perhaps to change the attire or correct the proportions.

attempts in favour of using augmented reality apps on their phones or computers.

Interestingly, Gardner notes in *Art, Mind, and Brain* that beginning at around the age of six or seven, children take a greater interest in the real world. Children of this age begin to show a preference for

A dressed-up girl drawn by Isabelle, aged 10, courageously includes the hands, which are notoriously difficult to draw.

'Party of Naked Women Playing in the Garden', by Marina, aged 10, was inspired by a combination of seeing an image of Henri Matisse's painting *Nasturtiums and the Dance* and a sex education class – both in school.

Marker self-portrait with dazzling eyes by Anna B., aged 10.

Self-portraits by Jazzlyn, aged 10–11. The figure on the right is crying because her grandparents could no longer take care of a dog and it had to be given away.

Pencil self-portrait by Isabelle, aged 10, in which the facial features and the heart-shaped locket take precedence over the outstretched arms.

'Portrait of my friend Maria', by Beatriz, aged 12. Note the guidelines drawn to ensure correct placement and facial symmetry.

This contour line drawing self-portrait by Astrid, aged 10, shows a personal solution to the challenge of drawing nostrils and eyelids.

Self-portrait with a broad smile drawn in pencil by Talia, aged 8.

Portrait drawing from life of 'My Mother on the Terrace' by Patricio, aged 10. Note the pose of the hands, the accessories such as the bracelets, earrings and the sunglasses perched on the mother's head, and the table with various objects on it – all carefully observed.

more traditional paintings, because they are more realistic and lifelike than many modern and contemporary artworks. In fact, some children show a great preference for photographs over any paintings, because photos are, well, even more realistic and lifelike. Gardner's observation was made over thirty years ago. Today, with most children having ready access to cameras on their mobile phones, and while online photo- and video-sharing diversions abound, the value seen in being able to draw an image of a person may have already been eclipsed by other media.

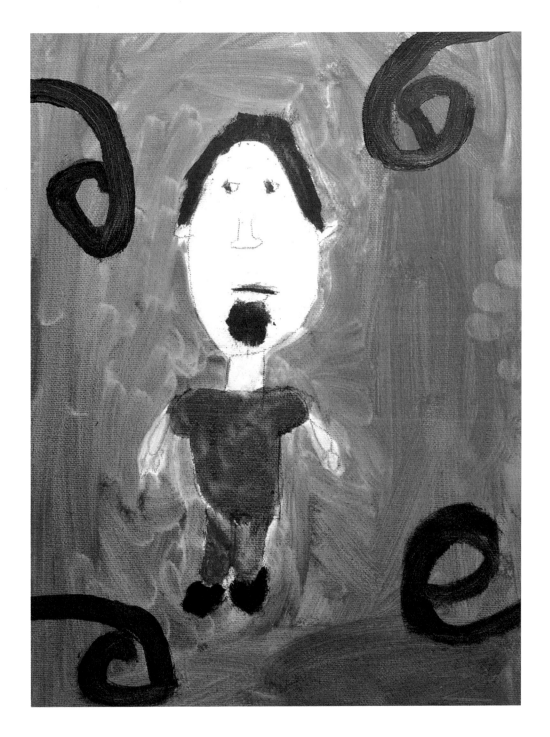

'Portrait of My Dad', painted on canvas board by Micaela, aged 8.

Pencil drawing of Goku, an anime character from *Dragon Ball,* by Jaime, aged 12.

Many pre-adolescent boys and girls often feel more comfortable drawing an anime character, or one from a favourite cartoon, movie or comic strip, than drawing an image of a real person. As these characters are usually drawn – either by hand or using a computer – with plenty of exaggerated, absurd or outrageous features, pre-teens feel less self-conscious about their perceived lack of technical skill. Some youngsters create their own unique images, but others prefer to copy or replicate already existing characters.

Finally, drawing as a spontaneous artistic expression usually ends at this stage. Edwards refers to the beginning of adolescence as an artistic crisis period, when there is a disparity between children's 'increasingly complex perceptions of the world and their current level

of art skills'. Some researchers feel it is because youngsters are overly critical of their own work and get frustrated when they cannot draw things in a way that looks real or 'right'. Or perhaps, at some point, someone made a thoughtless, sarcastic or derogatory remark, or some well-meant critique was misinterpreted by the child as negative. Many adolescents basically give up. Other scholars believe that drawing may no longer be the most suitable way for these young people to express and deal with their own feelings. And others – many others – suggest that drawing ends because children are no longer provided with quality art instruction in secondary schooling, or middle or junior high school, or that parents devalue the study of drawing as a less than 'serious' activity – one 'without much of a future'. For whatever reason, if drawing is not encouraged either by parents or teachers, children's drawing development just stops here. In fact, without further instruction, many adults continue to draw at this pre-adolescent level – that is, if they even attempt to draw at all.

Owen, aged 10, drawing an animal.

How?

Encouraging Your Child to Draw

Creative self-expression is tremendously satisfying for children, especially when they feel they can express themselves openly and without fear of judgement. While children naturally have a strong impulse to draw, attitudes towards drawing form at an early age and can affect one's creative capacity in later life. W. Lambert Brittain wrote, 'If it were possible for children to develop without any interference from the outside world, no special stimulation for their creative work would be necessary. Every child would use his[/her] deeply rooted creative impulses without inhibition, confident.'

It always makes me sad to hear that some classroom teachers, in what I'm sure are well-meaning attempts to bring a modicum of art into their classrooms, still pass out photocopied sheets and have children colour and cut out identically generic, smiling jack-o'-lanterns around Halloween. I mean, isn't the whole idea to make a pumpkin look cool and unique? No two children – even twins – express themselves in exactly the same way. But drawing helps bring

out each child's personality. Parents who encourage their children to draw help them build creative skills through imagining, exploring, experimenting, inventing, fantasizing and visualizing – all of which will help build children's self-confidence and their understanding of the world around them.

There are several ways parents can encourage even young children to express their ideas, thoughts and emotions through drawing – without feeling guilty about being overbearing. When children are provided with space, materials, opportunity, guidelines, time and the right attitude, they can work freely, engaging in new ways of thinking and problem-solving while at the same time developing concepts that give visual form to their own unique experiences.

Space

Sometimes 'space' refers to more than just a physical location. For those readers fortunate to live in a large dwelling, designating one specific area in which children can draw may be easier than allocating precious available space in a small flat. But the physical dimensions of the drawing space can actually be less significant than the way it is perceived. The very act of setting aside a special space for children's creative 'work' automatically imbues it with importance and implies parental respect for the activities that go on there.

It is worth noting that in the much-lauded early childhood programmes of Reggio Emilia, in northern Italy, the concept of space refers to the overall learning environment. In the Reggio schools, all children's classrooms have a designated art space called the *atelier*, or art studio. The immediate presence of the *atelier* and its ongoing availability to the children are unspoken reminders of Reggio's commitment to the understanding that art is important to learning and knowledge-building.

Play date: Ruby, Sybil and Leigh at the art table.

Taking a cue from Reggio's successful model, a child's home drawing environment should be clean and orderly, have sufficient light and be readily accessible. In addition to having a place to work and materials to work with, the drawing space should be relatively free from visual overload. (Most kids already absorb plenty of this by simply being 'out there' in today's visual and material culture, not to mention their almost constant exposure to images via TV, the Internet, photo-sharing apps, YouTube, electronic games and countless other apps.) In other words, parents are advised to resist the temptation to make the at-home studio space look 'artsy' or 'cute' by tacking up posters or adding shelves for stuffed animals and favourite figurines. The

child's drawing environment should be neutral enough to encourage imagination, exploration and experimentation. When in doubt, opt for simplicity and recall the all-famous quote by the modernist architect Ludwig Mies van der Rohe: 'Less is more.'

There is hardly a dearth of child-friendly furnishings, with desks, tables, seating and easels readily available online and from big-box stores, second-hand shops and even neighbourhood garage or car boot sales. But a designated drawing space might also be at one end of a long coffee table, in an alcove under the stairs, at a sturdy pop-up shelf hinged to a wall or windowsill, or even in the lower half of a seldom-used closet. What is absolutely essential is that the child feels comfortable. Furniture meant for grown-ups may feel awkward for children. That means an adult-sized chair may need an extra sturdy seat cushion to accommodate little knees, or so that the drawing paper on the tabletop is easily within reach and can accommodate a full range of both hand gestures and arm movements.

For children, painting at an easel can feel like a luxurious adventure because they are basically drawing on a larger scale with bold strokes of liquid colour. Drawing at an easel affords children a greater range of motion, strengthening muscles while enabling them to use large arm gestures. Besides this, the experience of creating while standing upright is also fun, as it presents new challenges and offers a different perspective.

A good children's easel should be a sturdy, two-sided floor model that won't collapse or tip over easily. It should also be the right height for children to work at comfortably. Constructed like a sandwich board, a double-sided easel offers the added perk of encouraging social interaction between two children, who can be working on opposite sides simultaneously. Some artist easels for kids have a blackboard on one side – great for using chalk markers or for practising brushstrokes using just water – and a white board to use with dry-erase markers on

the other. Some easels use rolls of paper, and others require individual sheets to be attached at the top with large clips. Easels usually come with trays for holding paints and water containers. But children will also need at least one long-handled easel brush that affords them ample distance away from the slanted easel surface.

Again, having a positive, nurturing attitude about the child's drawing environment is key. Children are quick to pick up on even a

Pre-teen Isabelle, aged 10, has drawn a charming group portrait of herself (on the right) with two girlfriends, all sporting ultra-feminine hairstyles and wearing fashionable clothing and footwear.

The fictional Belgian cartoon character Tintin, with his distinctive round face and
quiff hairstyle, is whimsically reimagined as a girl by pre-adolescent Marina, aged 10.
A figure that seems to be dancing has been sketched below.

One-point perspective study of a small town by Julian, aged 9–10, who clearly understands the idea of a vanishing point on the horizon but is still perfecting exactly how to do it.

shred of parental uneasiness about potential paint drips or stains on clothing, floors and furniture, or scratches that might be left by pens or hard, pointy pencils on soft wooden surfaces. It goes without saying that parents need to think ahead and prepare the area in advance, simply because they are the grown-ups. This prep is part of ensuring that the child's drawing experiences will be happy and positive and that drawing will be an activity s/he wants to engage in again and again.

Let's get real: we're talking about kids, so drips and other accidental messes are pretty much inevitable. And a parent can't always have kids paint while they're in the bath, right? So if this is going to be a major source of anxiety, finding a piece of non-slip carpet runner

and having a clean rag and an old shirt on hand are highly recommended. Sticking with washable mediums can also help alleviate the fear of permanent stains. And pencil scratches on tables can readily be averted by drawing on pages while they are still attached to the rest of the drawing pad, or by taping a sheet of paper to a makeshift 'drawing board' fashioned from cardboard or even an old magazine. Such preventive measures evolve from personal experience. I always loved drawing and painting as a youngster but could never figure out the logic of messing up a perfectly clean rag or fresh paper towel when wiping my hands on my clothing seemed so much more expedient. Besides, would anyone really care if Jackson Pollock's jeans were a mess? Of course, as a youngster, I never had to do the laundry.

Needless to say, older children tend to seek out more privacy for their creative, self-expressive endeavours, often because they fear being judged or 'not measuring up' to some perceived external or self-imposed standard. Sometimes, they just want to try out new ideas or techniques in private. Whether they are illustrating something to accompany a school project, designing dazzling superhero fashions or drawing the biggest, baddest space aliens ever, older children often take their drawing activities with them into their rooms, a den, an attic or some other semi-private space. For this age group, large, lightweight, Masonite drawing boards are durable, portable and can be used just about anywhere, including back gardens, parks or the pergola at one's grandparent's house. (A number of museums even provide these free of charge for visitor use at specific times and in specific galleries.) And drawing boards will work with all sorts of body postures, such as sitting at a table, sprawled on the floor, curled up on the bed or even balanced on one's knees in the back seat of a car during a family road trip.

Lastly, the drawing environment should feel safe for children so that they feel free to experiment, express their feelings and create

Boaz, aged 8, drawing in his sketchbook.

images they may or may not want to share with others. Most young children do want to know that a parent is nearby, especially if they need help opening marker caps or just want a fresh sheet of paper clipped to their easel. But some children will purposely change what they draw if they know an adult is watching them. Sometimes they will draw what they think the adult wants them to draw. Sometimes they will scribble with a vengeance. And sometimes they just feel self-conscious about being watched too intently. As will surely prove helpful in other situations, parents may want to practise perfecting their skills of unobtrusive observation.

Tools and Materials

Do you remember how thrilled you were to get a brand-new box of crayons at the beginning of each primary school year? You may even have had a favourite crayon colour that you used on everything or that you might have saved for only the most special drawings. And do you remember the slight twinge of disappointment you felt when the first crayon of your brand-new box snapped in two?

It might seem a bit odd, but ask a few grown-ups if they have any youthful recollections about crayons and you'll undoubtedly hear some heartfelt tales. One of the saddest told to me has to be from a fellow who once was the tallest boy in class and was seated at the farthest table, which meant he was always last in line for his class's communal crayon trough. More than fifty years later, he still cringes at the embarrassment of being 'forced' to colour his squirrel bright orange because every brown, grey and black crayon had already been snatched up by his classmates!

It should therefore seem obvious that, in addition to a space, a variety of interesting, age-appropriate, good-quality art materials is absolutely necessary for expressive drawing to take place. Moreover,

better-quality, more interesting and varied materials will have a direct and observable effect on how motivated a child will be to draw.

But first, a very important safety note. As any parent can tell you, the first thing a toddler will do with a crayon is put it in their mouth. And as any art teacher can tell you, the sweet-smelling fragrances that manufacturers add to glues, paints, markers, coloured pencils and other materials labelled as 'for children' or 'for young artists' are almost too yummy-smelling for youngsters to resist tasting them. Therefore, when buying any art materials that will be used by children, be sure to look for the words 'non-toxic' on the package. Sometimes, on products from the USA, you may also notice a circular AP (Approved Product) seal from the Art and Creative Materials Institute (ACMI), certifying that toxicologists have tested the product for safety. And while some early childhood and/or children's art bloggers may disagree, besides the fact that too many children around the world go hungry, this is one very compelling reason *never* to mix up food and art stuff in the minds of kids by introducing apple sauce, pudding or any other foods as a medium for finger painting.

The inordinate number and variety of materials touted as children's art and drawing supplies can be overwhelming to any parent. If you have access to an actual – meaning bricks and mortar – art supply store (or a stationery shop that carries art supplies) you can probably spend some time perusing options with your child, such as pads of paper, and in some cases testing out different marker pens and other drawing tools. Regardless of how odd a pastime this might seem to some, to many others, including a serious pre-adolescent artist, the chance to actually check out 'new' and 'professional' drawing supplies can be immensely gratifying – especially if s/he gets to take some stuff home afterwards. And allowing youngsters to make their own choices – even if it is about a type of marker – builds self-confidence and encourages independent thinking.

As far as drawing supplies go, there are two basic essentials: something to draw with and something to draw on. In terms of drawing tools, there is so much to explore and the choices are overwhelming. Today's crayons can be thin, thick, round, hexagonal, chunky or triangular – the last of which can help young children achieve a better grip. And their density can be softer, for smoother application, or harder for less breakage. Crayon composition is no longer simply wax and colour pigment; now there are choices that include beeswax, and gel crayons – both of which are highly recommended because they glide easily on the paper and take a lot less muscle to produce strong, brilliant colours. And there are also neon colours, glitter crayons, paint sticks, Cray-Pas (oil pastel sticks) and water-soluble crayons that can be blended. Mixing things up is a great way to motivate young artists. Parents may be surprised at how enthusiastically their children embrace a new drawing medium – especially one with a soft, creamy texture and vibrant colours. As youngsters grow and develop, they will tend to add more details into their drawings, such as fingers, eyelashes and whiskers – elements that might call for a more 'refined' drawing tool. Hence, the rule of thumb is: the older the child, the slimmer the crayon.

Older children with a serious interest in sketching might enjoy a mini-set of assorted drawing pencils. Pencils offer greater drawing flexibility than crayons or markers because they can be used for shading and other effects. Graphite pencils come in several numerical lead grades: H = hard and B = soft. Four pencils (2H, HB, 2B, 4B) should offer enough of a range for experimentation with different drawing effects and techniques. Choice in coloured pencils is always a toss-up, because it is tough to find an inexpensive pencil with a smooth, lush colour that doesn't also crumble easily. However, a word of advice is to avoid cheap coloured pencils, because if the lead is too hard, the paper beneath will invariably tear with the vigorous application necessary

Jaime, aged 12, absorbed in developing his pencil drawing.

to cover broad areas or achieve more intense colours. Undoubtedly, after a while, those cheap pencils will probably be left in the drawer. It is better to opt for a good brand of coloured pencils, even if you start your child off with a smaller set of limited colours. Needless to say, pencils also need sharpeners and, most likely, erasers. Novelty erasers shaped like Hello Kitty may be cute to look at, but a simple, inexpensive white eraser does the trick every time. Just be sure it is large enough for the child to grasp it easily.

Children enjoy the variation of drawing on different colours and sizes of paper. However, while paper comes in different sizes, weights and textures, parents often rely on plain white copier paper as the primary drawing surface for their youngsters. Copier paper is okay to use but it might prove frustrating to children under certain circumstances. This is especially true for toddlers, whose drawings demand a larger size of paper because they tend to scribble right off the page and onto the table. Besides, like newsprint, copier paper is relatively thin; it won't stand up to heavy crayon colouring, and some felt markers may cause 'bleeding' through to the other side. Medium-weight Manila drawing paper is fine for most drawings. Certain drawing mediums, such as oil pastels, paint sticks, chalk markers, pastels or glue (yes, glue), really require a heavier grade of paper, preferably with a texture, or 'tooth'. Many types and sizes of paper, including coloured construction paper, are available in pad form at different price points. A pad bound with flexible glue – and where single sheets can be removed easily – is preferable to pads with spiral binding. Older children may prefer the cachet of using a bound sketchbook, but younger children do not yet have the manual dexterity to hold the pages open while they draw.

Since working with tempera or poster paint is like drawing with a brush, brushes and other applicators are other tools to consider. First, there is probably not one person in the entire world who has

ever had any success with those scrawny little brushes that come with 'school-grade' (read: cheap) sets of paints, be they poster paints, gouache or watercolours. On the other hand, there is absolutely no reason to buy children under twelve years of age artist-grade brushes, either. Toddlers will need one or two inexpensive easel brushes with flat-tipped white boar bristles and, preferably, with long wooden handles and metal ferrules (the part that holds the bristles to the brush) so all the bristles don't fall out. Do not be seduced by brushes with nylon bristles, because they are meant for acrylic paint and won't hold tempera paints as well. Do not be seduced by brushes with bristles that have been stuffed and glued into cheap plastic handles. The bristles will fall out the first time your child leaves the brush in water a minute too long. The brush should have bristles that measure about the same width as an adult thumbnail – #9, #10 or #11 brush size is perfect. Painters ages six and up will need a few school-grade round paintbrushes, again with wooden handles and metal ferrules, in sizes small, medium and large. These brushes should be made from soft, natural hair that will easily re-form back into a point after rinsing. (By the way, before all those nice new paintbrushes start shedding more hair than the family dog, parents might want to demonstrate just how to gently rinse brushes in a water container and then wipe off excess pigment with a rag or paper towel.) Foam brushes from the hardware store and foam-tipped refillable plastic bottles are fine for school situations, but they do 'drink up' a lot of paint. Some children seem to like the novelty of those 'dot-dauber' paint applicators that are specially made in sets for kids. (Similar-looking daubers sold to use on bingo cards are not appropriate for children.) But paint sticks – solid tempera paints in twist- or push-up tubes – are the best of all. A word about paintbrush storage: after a thorough washing in soap and water, all brushes should be placed vertically to dry in a container – handles down and bristle, hair or foam ends up.

If buying art supplies in a bona fide shop is not a possibility, you are probably stuck hunting for stuff online. When in total doubt, there is not much to go on except trial and error. For older children, one suggestion is to opt for products made by brands

Vega, aged 9–10, uses watercolours over pencil in her depiction of an old vest on a coat hanger. Her careful use of light layered washes – both for shadows and for the creases inside and outside the vest – make her image look more realistic and indicate professional art instruction.

In this imaginary landscape, Anna B., aged 11–12, experiments with colour blending using watercolour washes over crayons.

such as Faber-Castell, Caran d'Ache and Prismacolor, which also all manufacture a line of products specifically for children. In addition to engendering pride, these will most likely help produce better results. There's no harm in starting younger children out with less costly brands. But be aware that budget materials may turn out to be more watery, contain less colour pigment, break more easily or require too much pressure for little hands to master.

Providing good-quality materials that are in good condition is important. Also important is being aware of your child's special needs or idiosyncrasies. Some children will absolutely refuse to use a broken crayon. Others won't use anything like coloured chalk unless a paper is wrapped around it so their hands won't get soiled. And parents of left-handed children need to be aware that, because of smudging, it can be frustrating for them to draw in a spiral-bound sketch pad or with markers and other mediums that don't dry quickly. Similarly, watercolour paints can be difficult to control, because they are, well, dependent on added water, and water can easily run or lead to unwanted splotches. They are a perfectly fine medium for older children who want to experiment with layered washes and blending effects and who have the patience to wait for each layer of paint to dry before continuing. But they may prove somewhat discouraging for children under the age of ten, unless, of course, seeing how little pools of coloured water flow into one another is a fun experiment in itself.

Opportunity and Guidelines

Learning how to express oneself is critical to every child's mental, social and emotional development. Parents can encourage their children's self-expression through drawing by ensuring they have ample opportunities and easy access to what they need. As drawing is a healthy way for children to express their emotions, whether anger,

excitement, sadness, happiness or fear, if they don't want to share feelings out loud, perhaps they might be coaxed to 'say it on paper'.

While certain art materials will undoubtedly require adult supervision, even young children can learn simple guidelines for using basic, age-appropriate drawing supplies on their own. To head off potential aggravation, parents should be clear about what is and what is not acceptable both in terms of materials and the drawing space. For example, using crayons on paper is fine; using them on other surfaces is not. Try to replace caps on markers so they don't dry out. Fetching and emptying water containers requires the help of an adult. Any supplies that are used should be returned to their proper container. As children grow, they will be able to set up, work and clean up after themselves more independently.

Time

It goes without saying that when children are very young they can quickly churn out scribble after scribble without much regard for what they are doing. But as they get older and become increasingly involved in expressing ideas in their art, children are no different from adult artists in that their drawings take time.

Regardless of one's age, the creative process usually comprises a number of steps. Assuming drawing materials are ready and available, the process often starts out with observing or remembering something, which sparks an impulse or idea. The next step is some sort of analysis, where the child (or adult artist) goes over a thought, event or something or someone s/he observed in his/her mind, usually until a moment of insight or inspiration is reached. Eureka! The third step is experimentation with the drawing tools, materials and techniques. (This is what erasers are for.) Last is evaluation, where, after the artwork has been created, the child (or adult artist) might think about

what s/he drew in relationship to what was in his/her mind. For younger children, when a drawing is done it's done. But as children get older they become much more critical of their own work. (This means parents will often find that the waste-paper baskets of adolescents are full of half-finished, crumpled-up papers.) Naturally, for both the child and the adult artist, the creative process happens without thinking too much about it. Drawing can take time, and parents need to be aware of and respect this. In other words, in addition to space, materials and encouragement, kids need to be given ample time to express themselves visually.

Some organization tips: store drawing supplies so that they are neat, inviting and accessible. Put the most frequently used supplies, such as crayons, markers and pencils, in plastic boxes so that the contents will be visible. Loose paper and pads can be stored in a drawer, folio or flat box. If possible, make it easy for even a young child to get a few basics, such as crayons and paper, without having to ask a parent for help. This builds self-esteem and encourages independent thinking. And try to vary the drawing materials to keep children motivated.

Attitude

Remarks made by parents and caregivers – even those that are meant to be supportive – are taken quite seriously. They can greatly affect a child's confidence, spontaneity, desire and motivation to draw. Even well-meaning comments can be misconstrued by the child as negative or critical. Youngsters are eager to please and will pick up on a parent's cue. In the hope of fostering creative potential, here are a few suggestions about what to say and what not to say.

First, never, ever let your child hear you say, 'I can't draw'. When a child hears these words from a parent, s/he thinks, 'I'm just like Daddy.' When you proclaim, 'I can't draw', it basically sends the message that

it's okay if they don't try to draw or that if they do, they probably won't be any good at it either.

In the same vein, resist the temptation to correct anything or draw anywhere on your child's drawing. And never, ever, ever make an effusive value judgement such as 'This is so beautiful', 'You are such a great artist' or 'You're going to be the next Picasso.' Remember, in these early years of childhood, the aim should not be how to teach a child to draw, or how to draw better. Children's drawings reflect how they see, what they know and how they feel about things in the world around them, at that very moment in time. As children develop and change, their drawings develop and change as well.

If a child asks you to draw something for them, it is better to suggest that s/he tries to do it him/herself, but use cues to help the child focus. For example, if you are asked to draw a cat, you might say, 'Let's think about what a cat looks like.' 'How many legs does it have?' 'What kind of tail does it have?' 'What type of ears does it have?' 'How does a cat move?' 'How does it sleep?' 'How does a cat feel when you touch it?' 'What do you think about when you think about a cat?'

When presented with an indecipherable image, hold yourself back from asking 'What is it?' Instead of commenting on what you can't see, comment on what you can see. For example, 'I see you made some long, curved, red lines over here and some short, squiggly, blue lines over there.' Do not say, 'Is this a picture of Mummy?' If you do, children will automatically assume that is exactly what you want them to draw or what you want to see. For a while after that, they will probably say that every other drawing they present to you is a picture of 'Mummy'.

When presented with a finished work, even if you think you know what the content is, it is advisable to say, 'Tell me about your drawing' or 'What is the title of your drawing?' You can also offer comments and questions about what you see. For example, 'I see a

The scale of this cat is enormous in comparison to the size of the trees and bushes around it. Sara, aged 7–8, has used colour and positioned the cat to emphasize its most distinguishing features: four legs, sharp claws, round face, big round eyes, orange, pointed ears and long whiskers that even seem to touch the clouds. The placement of the small tree on the left underscores the importance of the length and curve of the cat's tail.

big castle with flags on the roof and someone looking out of the window.' 'Who lives in the castle?' 'Who is at the window?' 'What is s/he thinking?' 'What do the flags mean?' Open-ended comments such as these can also help children create a story about their drawing.

When young children bring their artwork home from nursery or preschool, teachers will often have written the subject of the work on the back of the paper along with the child's name, or attached a brief description of it, ostensibly relayed directly to the teacher by the child. Naturally, parents should offer some positive comments about specific elements that are visible in the work itself, such as an energetic green squiggle over here or a cluster of blue dots over there. And it's perfectly okay to ask the child to tell you more about his/her drawing. However, do not automatically assume the description written by the teacher is still in the child's mind. Young children may not recall what they said earlier about their drawing or they may change its meaning entirely. When older children draw at school, unless the work was specifically made in art class, the artwork is usually an illustration of something they have been studying in class and its subject is fairly obvious. Drawings worked on at home for a school project are often focused on fulfilling assignments given by the classroom teacher. In these instances, parents can certainly use the subject of the drawing to probe a bit more into their child's viewpoint of exactly what s/he is studying in class.

When children draw spontaneously they are often expressing their feelings about someone, something or some event. This means that, in addition to love and happiness, their drawings might convey fear, anger, hatred, confusion, loneliness or other strong emotions. Drawing can be a productive way for children to express either negative or positive emotions and for them to work out their feelings on paper.

Obviously, it is a lot better to depict one's tormenting older sibling as a menacing monster in a drawing than it is to take retaliation

Marker drawing of a medieval castle by Isabel, aged 5–6, which depicts specific architectural details such as the arched windows and the crenellated top of the castle wall. Also note the princess wearing an elaborate period headpiece gazing out of a window and the two Spanish flags waving in the wind.

by dumping all his/her clothing out of the window in real life. And, it is certainly healthier for children to draw their anger or make up redemption fantasies after being scolded by parents. Just think about what happened to Max after he was sent to bed without his supper in Maurice Sendak's beloved and award-winning picture book *Where the Wild Things Are* (1963). Sometimes, however, parents may suspect that a child's drawings might depict something darker or hard to vocalize. While I am absolutely in no way suggesting that parents play the role of trained child psychotherapists, according to the Jungian psychologist Gregg Furth there are certain clues parents can pick up

A marker sketch by Ayla, aged 6–7, focuses on Roman soldiers who are lined up and facing in the same direction – all with plumed helmets, matching uniforms and shields. The soldiers' faces are individualized by their freckles, eyelashes and snippets of hair. The overlapping line of figures shown in profile shows a degree of drawing sophistication.

Crayon and pencil illustration of settlers landing in America by Julian, aged 8–9. While no people or animals are shown, attention is focused on details of the ship itself and its arrival in a pastoral new land.

simply by looking at a child's drawings. First and foremost, does the overall mood of the drawing seem happy, sad, fearful or otherwise? Is there anything that seems exceptionally odd, grossly distorted, extended or weirdly out of place? Who or what is the central focus of the drawing, and who or what is pushed off to the sides? Do any of the characters seem lonely, compartmentalized or separated from one another by drawn barriers? Is there something or someone obviously missing that should probably be there? Again, parents should *never* try to play therapist, especially as children can change their feelings

and moods rather quickly. And do remember the earlier example of how one classroom teacher misconstrued the feeling inherent in a child's painting because the portrayal of his new pet – a sad-looking lop-eared rabbit – seemed uncharacteristically depressed *to her*. But if parents sense something is 'off' about their child's drawing, they can and should certainly ask him/her to tell them more. Rest assured that most of the time it is absolutely nothing.

Coloured pencil drawing by David, aged 5, illustrates a scary event – a huge fire raging in an block of flats in the city. Note that the fire station, doors open and engines ready to go, is massive compared to the other buildings, streets and onlookers. Also note the attempt at perspective and the way three-dimensional space has been represented: the buildings lining the street at the right, meant to be standing upright, look as though they have toppled over.

Sophia, aged 5–6, has made a happy-looking marker drawing of an embellished unicorn in a field of flowers. The unicorn stands under a rainbow with the moon and twinkling stars all around.

Finally, in today's parenting climate, there are conflicting attitudes about whether or not to display one's own child's artwork at home, and, if so, how? One camp feels that children's drawing development, much like their physical, social, mental and emotional development, is fluid. Therefore, drawings can certainly be displayed but not necessarily feted. For these folks, temporarily hanging a drawing on the fridge, the kitchen corkboard or in the child's own room is appropriate. Another group feels that displaying a child's drawing in any of these sites shows the child disrespect. To them, a good drawing, regardless of who drew it, should be framed and hung in a place deserving of it. Yet another group proudly and frequently posts digital images of their children's drawings on social media sites. This is all so curious, especially since, soon after preschool children usually do not remember their own drawings and paintings.

Where is the best place for your children's drawings? Wherever makes your family happy! To preserve the drawings, scan or photograph them all if you would like to compile a 'drawing history'. Save the drawings themselves – the ones you like best or ones that mean something special to you – in a flat portfolio with the date written on the back in pencil. One day your family will open the 'time capsule' and ask, 'Where did the time go?'

'Baddie' drawn and named by Ayla, aged 5–6, depicts a somewhat menacing figure with a patch over one eye, oversized teeth, and a sword or knife in one hand and a shield in the other.

Vintage tempera painting done in art class by Erik, aged 8–9, shows two brothers and their dog walking in the snow. Note the careful attention paid to the patterns and textures of the winter clothing – knitted sweaters, caps, scarves and mittens – and the cold, rosy cheeks of the boys. The black outlines and sponge-daubed background were added on the suggestion of Erik's art teacher.

The Good, the Bad and the Maybe

Unfortunately, there are some all-too-common practices, usually the suggestion of well-meaning caregivers and harried parents or teachers, that sort of look like art but instead can squelch the very spirit of children's creative expression. For children, the value of art, and specifically drawing, is that it is a pleasurable activity that enables them to freely express who they are by depicting things as they see them, know them and feel them. But there are practices that, unfortunately, do little more than push children into a mould and crush their attempts

to be unique, strong, independent-thinking individuals. Hence, to be forewarned is to be forearmed!

Colouring books: It is impossible to visit the art section of a big-box toy superstore without being overwhelmed by colouring books based on the most recent hit animated movie for children. Unlike the relaxation felt by some grown-ups who swear by the current adult colouring book craze, having to colour within thick black lines that are meant to represent an adult's idea of some cartoon character is not tremendously satisfying for young children. In fact, children will often superimpose their own scribbles without any reference to the image beneath. But herein lies the parental dilemma. It is obvious that such colouring books are product tie-ins, created to perpetuate interest in the movie and enrich the movie studio. Using them proves frustrating for young children. But they really want them.

Stencils: In too many schools, primary-school children are sent home with cookie-cutter images of black cats around Halloween time, white-bearded Santas around Christmas, and paper plates identically decorated to seem like lions and lambs come March. Such art projects only teach children to conform – not to express themselves.

Workbooks and kits: Products that offer children 'stuff to do' are just that – workbooks and kits. They may employ art materials but they have nothing to do with art. Continued use of stencils, connect-the-dots puzzles, mazes, tracing, paint-by-numbers kits and those 'magic painting kits' (where an adult artist's image appears when water is brushed over a seemingly blank page) can be stultifying to a child's innate desire to create and to his/her ability to think creatively as an adult.

Children's art exhibitions and contests: Children are usually proud that their art is on display, so exhibiting children's work is good – as long as both the drawings and the children are treated with respect. That means drawings created by children of a similar age should be

Nidorina, a character from the popular *Pokemon* series, painstakingly drawn in pencil
by Charles T. at the age of 9–10.

This cityscape, drawn in the late 1950s by a then 12-year-old Ira Joel, was inspired by the cover illustration for *A Year in the City* (1948), a Little Golden Book written by Lucy Sprague Mitchell.

Sensitive portrayal of a walrus created in an instructor-led art class, using watercolours over pencil, by Juno, aged 8.

grouped together in the same location and that the 'installation' looks as professional as possible, so that works are hung level and neatly, with some 'air' around each drawing. On the other hand, since it is important to appreciate every child as a unique individual with different needs, interests, abilities and experiences, there is absolutely no reason to promote competition among primary-school children. Drawing contests for children this young go against the universally accepted idea that every child's work has validity because it is an expression of him/herself. Besides, is anyone truly qualified to rank the drawings of different children against each other?

Copying: As a rule, copying is usually frowned upon by art educators, especially for young children, because it can never be a true

expression of the copier's personal ideas and emotions. The classic example of how copying can stifle creativity is a four-year-old's charming depiction of a bird flying away, created prior to being exposed to a flock of birds in a colouring book, drawn to resemble a bunch of wide letter Vs. After exposure to the colouring book, the same girl made another drawing of birds where she tried to emulate the Vs. However, as children become older, they have an increasingly strong impulse to draw things 'the right way' or depict them as realistically as possible. It would be difficult for anyone who has never seen a walrus up close to accurately draw a walrus without at least studying a photograph. And few ten-year-olds will ever have the opportunity to carefully study the costume or musculature of a favourite cartoon or superhero at first hand outside books, magazines, comics or online. So there are exceptions to every rule, especially when a source is used expressly for inspiration or to hone one's art skills.

Philip Matsikas, an exemplary instructor, has been the fifth-grade (age ten to eleven) fine arts teacher in the Lower School of the University of Chicago Laboratory Schools for many years. About twenty years ago he started '5th Grade Fine Arts Notecards ©', in which each student selects and 'reinterprets' a famous work of art – in miniature – as an original watercolour painting. The cards are then printed and sold in sets to benefit the school. When asked if parents or other educators ever questioned children 'copying', he wrote the following:

> By interpreting – in miniature – a piece (of their choosing)
> from the history of world art, students go far beyond the
> traditional study of art history and actively take *ownership*
> in its creation. During the course of this long-term project,
> important learning occurs as students observe with increasing
> accuracy and use the tools of visual expression with growing

precision and confidence: Forms become more specific, color is mixed with greater subtlety, increasing skill and expressiveness is developed applying paint to paper. A virtual world of aesthetic learning is discovered in little more than twelve square inches of acid-free paper.

However, while there are certainly instances when copying may enhance the observation and drawing skills of older and/or artistically gifted children, especially under the guidance of a professional art educator, such practices can thwart the spontaneity of younger children, making them feel self-conscious or insecure about their own concepts and artistic expressions.

Drawing in the digital age: There are digital drawing software programs and many drawing apps that are specifically geared towards children. The question, however, revolves around how one wants to 'draw'. The majority of these programs, apps and devices are a far cry from the tactile experience of traditional drawing. But they can be portable learning tools for children that are fun to use.

Most of the apps designed for computers as well as for Android tablets and iPads use a similar format – even for kids. There are tile-like icon 'menus' from which users choose from a variety of drawing tools and effects, such as a pencil, brush, chalk, colours, lines, eraser, and so on. A click or touch selects the tool, which can then be used to 'draw' on the screen. Many of the programs designed for young children aged four and up, like Crayola Art Studio (PC only), are loaded with select-and-paste 'rubber stamps', wallpapers (background patterns) and clip art-style cartoon characters. Other top-rated children's drawing apps for Android are Kids Doodle, which has snazzy, neon-like effects, and Dipdap, which allows children to add their own doodles to several animated adventures. iPad apps include Doodle Buddy and Drawing Pad, which is also available for Android devices.

A bit closer to the immediacy of drawing on paper would probably be simple LCD drawing tablets. In more ways than one, these resemble an updated version of what can be described as an old-fashioned writing slate. Even young children would find it easy to doodle on these, but the novelty can wear off quickly. As of this writing, some of the top-rated LCD writing/drawing tablets for children are manufactured by V.one Technology (Smart Life), NEWYES and VPRAWLS.

For more advanced technology and nuanced drawing, Wacom manufactures a variety of devices called Wacom Intuos Drawing Tablets (which connect to a PC or Mac) and Wacom Bamboo tablets (which connect to an iPad or other mobile device). Employing a pressure-sensitive pen and downloadable software, these devices are intended to bridge the gap between the feel of traditional drawing and technology. But with their higher cost and complexities, they seem more appropriate for teenagers who consider themselves tech-savvy art students.

Pictures at an Exhibition

Years ago at the Guggenheim Museum in New York, a museum educator led a group of fourth-grade students (aged nine to ten) to stand in front of Picasso's painting *Head of a Woman (Dora Maar)* (1939). Using the classic inquiry method, she asked the children to guess what the famous painting was all about. Without skipping a beat, a sharp little girl said, 'Oh, that's a pig with hair.'

Children do not have the same concept of aesthetics that adults do. To preschoolers, the paintings that are hanging on a wall in a museum and created by others are not considered 'art', because, to them, 'art' is what they make themselves.

As Lowenfeld and Brittain point out, children undergo great changes in their physical and mental development between the ages

of five and twelve. This development is a key factor in the way children understand art and in their aesthetic judgements about art. When four- to five-year-olds look at paintings, they can identify, point out and make a list of familiar objects and colours. But they cannot relate the objects they identify to one another or try to make any sense of the work as a 'whole'. They cannot recognize a painting's 'mood', for example, nor can they figure out what the artwork tries to convey. It is not until the age of seven that children begin making those connections or try interpreting a picture. (Remember 'a pig with hair'?) And it is not until they reach the age of ten or eleven that their own vocabulary is at a high-enough level that the language and terminology used by adults to describe works of art starts making sense to them. Only then can they begin to determine what a painting is about.

Visiting an art museum with children probably seems like a daunting endeavour, especially for a parent who feels unsure about his/her ability to help the youngsters 'get something' out of the art. Museums have a reputation for being stodgy institutions – some still are. In fact, some galleries have artworks installed at such a height that no child could possibly see them unless s/he was lifted up. There are also galleries that are so dark, it is almost impossible to read the wall labels. And the worse offence, in my opinion, is that some museums avoid using seating in the galleries to keep visitor traffic moving. This makes lengthy visits difficult for visitors with physical challenges and for some elderly. But in recent years, museums have begun shaking off the dust to become more welcoming to diverse audiences, including families and children.

The important changes have gone beyond new architecture, the rearrangement of objects in the galleries and in educational programming. In the old approach to art history, there was only one 'truth' about an artwork's meaning, and that was whatever the scholars and curators said it was. The more recent approach to art history dictates

that there could never be just one 'truth', because the knowledge and life experiences of the viewer influence the interpretation s/he makes. In other words, everyone – even young children – can have valid interpretations.

This should be reassuring to parents who may not be as well acquainted with the art on display as they might like to be, or who are hesitant about dealing with contemporary art. Studies have shown that preschool children between the ages of two and three show no preference at all between abstract paintings and realistic paintings. However, younger children tend to react more positively to bright and contrasting colours, simple compositions, familiar objects and clear spatial relationships. It is only as children get older that, just as with their personal drawings, they strongly prefer realism and more complex compositions.

Perhaps the best way to get the most out of the art is to use inquiry, by hypothesizing about specific works of art using open-ended questions. There are no right or wrong answers, but everyone involved needs to support their answers by referring to something they see in the work. Visual Thinking Strategies, a USA-based programme primarily for schools, uses art appreciation to help students think and express themselves. The programme facilitator usually asks three questions of youngsters: what's going on in this picture? What do you see that makes you say that? What more can we find?

As children answer, the teacher (or facilitator) paraphrases the answer and expands upon it. For example, if a child says s/he notices a garden in the painting, the adult might say, 'I see you noticed the garden in the background on the left-hand side of the painting.' The goal is to ensure that the child feels his/her response has been understood. This type of approach is directly related to 'empathetic listening', a strategy that came out of Values Clarification (an educational method) and Cognitive Behavioural Therapy (psychology) of the 1960s and '70s.

Since one of the first things children draw are people, looking at other people seems like a natural place to start. Hence one of the best places for open-ended inquiry is the museum's portrait gallery. Children should be asked to pick the portrait of a person they would like to know more about. Ask the child to direct his/her questions to the person in the painting and then hypothesize about the answers that person would give, all based solely on what can be seen. Make connections. For example:

What do you want to tell me about your life?

What do you want to know about my life?

Why are you wearing that outfit?

Doesn't your high, tight, starched collar itch around your neck?

Doesn't your dress squeeze your waist too tightly?

What do you eat for dinner?

What is the name of the dog in the painting?

Do you always carry your sword? Is it heavy?

Tell me about your jewelled brooch.

Depending on the museum's collection, other galleries that are great for kids to explore are the ancient Egyptian gallery, the African gallery, the arts of China, Japan or India and the ancient Near East gallery. Pick one. Ask children to examine the art and look for clues that can answer questions about the culture(s) and the environment(s) that produced these art objects. Answers should not be made-up guesses but supported by what they can actually see: what were their belief systems? Who were the rulers? How were these objects used? By whom? What was daily life like? What types of plants, animals, geography and natural resources existed in the region from where these objects come? What did people wear? What was the weather like?

Another suggestion for younger children is to have a treasure hunt in which the whole family looks for artworks that contain the same element, such as angels, sports, cats, dogs, mythical figures or monsters. Each person chooses his/her favourite and explains 'why' to the others.

For a fun visit, each family member can choose a figure from a painting or a sculpture and freeze in the same pose for fifteen seconds. Or, as a group or individually, they can brainstorm a list of words that come to mind and share them.

Many larger museums have excellent tips for family visits on their website. Below are some of universal suggestions, borrowed from various museums, along with other tips gleaned from personal experience.

1. If possible, visit on a weekday, when there will be fewer people in the galleries than on a weekend.
2. Download any available maps or family activity guides from the museum's website and look them over before your visit.
3. Know where the toilets are located.
4. Check the museum's calendar online to see if there will be any special family programmes or youth workshops scheduled for the day of your visit.
5. Check the museum's policy regarding pushchairs (strollers). (Special exhibitions may have different rules.)
6. Check all bulky outerwear, backpacks and large bags into the cloakroom. Most museums offer a free cloakroom service.
7. Don't try to see everything. Plan on spending no more than an hour in the galleries, and plan to discuss a maximum of ten artworks.
8. Include stops at the museum café for a snack and at the museum shop to buy postcards or other souvenirs of your visit.

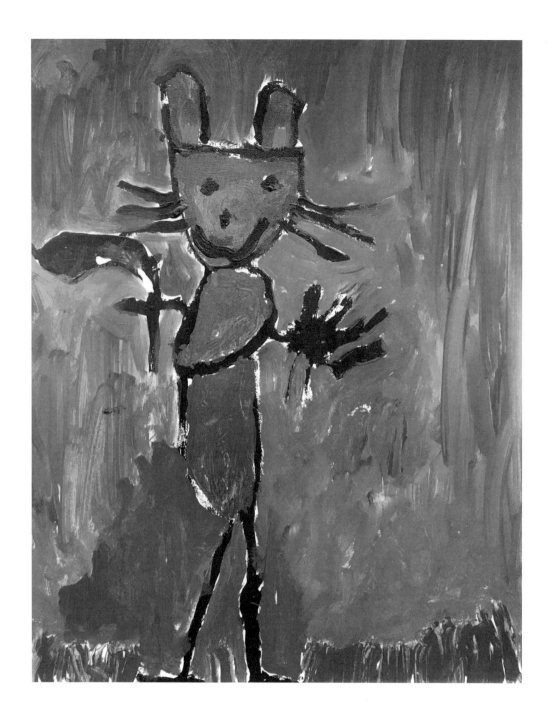

Tempera paintings inspired by the works of Marc Chagall (above) and Jackson Pollock (opposite), by Emerson, aged 4.

9. Review the museum gallery rules, such as no running, no eating and no touching the artworks, with your children beforehand.

10. Ask a museum guard if photography is allowed. Know how to turn off the camera's automatic flash. Be mindful of other visitors and don't block their view just to take selfies.

11. Share opinions.

One important note: regardless of your focus, in most medium to large museums with vast, encyclopaedic collections, your trip will invariably lead you and your children past a number of artworks portraying nudes in all their glory. I remember that, years ago, the Tate Gallery in London developed a self-guided family tour centred around the theme of what it then cleverly termed 'Rude Paintings'. In addition to

Crayon drawing by Julian, aged 6–7, inspired by Vincent van Gogh's *Starry Night*.

taking in some beautiful nineteenth- and twentieth-century master-pieces, this tour included a number of Late Gothic and Renaissance paintings of the partially bare-breasted Madonna nursing the infant Jesus. As a parent or caregiver, you might want to think about your own response in advance, should your children point and giggle at the anatomically correct Greek statues with their normally private body parts fully exposed in public.

Perhaps the most important tip is to focus your visit by concentrating on one or two galleries, or a specific theme, such as faces, animals, heroes and heroines, clothing, hats and headdresses, gods and goddesses, colours, armour and weapons, flowers or musical instruments; a specific culture, for example ancient Egypt, the Americas, Assyria, Mesopotamia, India or Africa; or a specific type of art, such as photography, sculpture, textiles, painting, murals, miniatures, manuscripts or mummies.

Did you know that studies have shown that exposure to high-quality works of art can improve the quality of children's own drawings? On pages 184–6 are some children's drawings that were inspired by works of art.

Finally, don't let your visit end when you walk out of the museum's doors. Back at home, ask children what was their favourite part of the museum, or what was their favourite artwork and why. Most museums collect and conserve art but usually exhibit only a small portion of their collections because of space constraints. As a family, you can look at more artworks from the museum's collection – especially works similar to those that interested your children – on the museum's website. In addition to filtering by period, artist name, medium and location, many enable searches according to topic or key words such as dragons, horses, children or transportation. And you can plan another visit to the museum to see different galleries and special exhibitions, or pick another museum to visit next time.

Works Cited

Brittain, W. Lambert, *Creativity, Art, and the Young Child*
 (New York, 1979)

Burt, Sir C. L., *Mental and Scholastic Tests*, Education Officer's
 Department, London County Council (London, 1922), available
 at www.archive.org

Cadwell, Louise Boyd, *Bringing Reggio Emilia Home: An Innovative
 Approach to Early Childhood Education* (New York, 1997)

Corcoran, A. L., 'Color Usage in Nursery School Painting',
 Child Development, xxv/2 (June 1954), pp. 107–13

Cox, Maureen, *Children's Drawings* (London, 1992)

Edwards, Betty, *Drawing on the Right Side of the Brain*, revd edn
 (Los Angeles, CA, 1989)

Furth, Gregg M., *The Secret World of Drawings: A Jungian Approach
 to Healing through Art* (Toronto, 2002)

Gardner, Howard, *Art, Mind, and Brain: A Cognitive Approach to Creativity*
 (New York, 1982)

—, *Artful Scribbles: The Significance of Children's Drawings*
 (New York, 1980)

Goodenough, F. L., *Measurement of Intelligence by Drawings*, Measurement
 and Adjustment Series, ed. L. Terman
 (Chicago, IL, 1926)

Hurwitz, A., 'Al Hurwitz Art Education Timeline Project', ed. Judith
 M. Burton and Adrienne D'Angelo, Program in Art and Art
 Education, Teachers College, Columbia University, 2014,
 http://hurwitz.tc.columbia.edu

Kellogg, Rhoda, *Analyzing Children's Art* [1969] (Brattleboro, VT, 2015)

—, and Scott O'Dell, *The Psychology of Children's Art* (New York, 1967)

Lowenfeld, Viktor, *Your Child and his Art: A Guide for Parents* (New York, 1954)

—, and W. Lambert Brittain, *Creative and Mental Growth*, 8th edn (Upper Saddle River, NJ, 1987)

Malchiodi, Cathy A., *Understanding Children's Drawings* (New York, 1998)

Pelo, Ann, *The Language of Art: Inquiry-based Studio Practices in Early Childhood Settings* (St Paul, MN, 2007)

Piaget, Jean, *Judgment and Reasoning in the Child* (Patterson, NJ, 1959)

—, and B. Inhelder, *The Child's Conception of Space* (New York, 1967)

Room 241, 'Art and Schools: Is Art Losing its Foothold in Elementary Schools?', Concordia University, https://education.cu-portland.edu/blog, 31 January 2013

Striker, Susan, *Young at Art: Teaching Toddlers Self-expression, Problem-solving Skills, and an Appreciation for Art* (New York, 2001)

Varnedoe, K., 'Your Kid Could Not Do This, and Other Reflections on Cy Twombly', *MoMA Bulletin*, 18 (Autumn–Winter 1994), pp. 18–23

Walker, Tim, 'The Testing Obsession and the Disappearing Curriculum', *NEA Today*, www.neatoday.org, 2 September 2014

Acknowledgements

Any book about the drawing development of young children owes a great debt to the works of numerous researchers, practitioners and writers in the fields of art and early childhood education as well as others in the fields of cognitive and clinical psychology. In particular, I would like to underscore the significance of Viktor Lowenfeld's 1947 publication *Creative and Mental Growth*, which even today remains one of the most influential art education textbooks. And although I never thought I would write this, I would like to credit the late Ora J. Gatti, my predecessor as Director of Art for the Worcester Public Schools in Massachusetts, who insisted that each and every one of her artist teachers – myself included – absorb Lowenfeld's text before ever stepping into a classroom. I would also like to mention another noted colleague and friend, the late Al Hurwitz, former Director of Art for Newton Public Schools and Chair of the Department of Art Education at Maryland Institute College of Art, who, with great enthusiasm and wit, often urged me to write a book such as this. Others who offered insights gleaned from professional experience were seasoned artists and art educators Philip Matsikas, Jacqueline Ross and my husband, Alejandro Torre.

I would sincerely like to thank Vivian Constantinopoulos, Editorial Director at Reaktion Books, for this opportunity and for her unwavering support, guidance and valuable editorial comments, not to mention her seemingly endless patience and steadfast good humour. Without her continued help and encouragement this book would never have been realized. I would also like to thank Aimee Selby for seeing this book through the editorial process, and Katya Duffy for her smart, modern book design.

A book such as this demands a myriad of images to accompany the words. I am deeply grateful to the parents, caregivers, friends, colleagues, former students and, in some cases, the now grown-up individuals who shared their children's or their own early artistic expressions and granted permission to reproduce their drawings and/or photos here. I wish to express my appreciation to Joshua Ackerman; Rebecca Teitz Ackerman; Jessenia Alvarez; Silvia Angos; Andrea Brady; Jason Bryant; Rafael Bustamante; Beth and Eric

Diner; Hymie Dunn; Gillian Ehlers; Mercedes Gertz; Patricio Guerrero; Santiago Guerrero; Ira Joel Haber; Robert Haberer; Leslie Hakim-Dowek; Maria Jofre; Tom Judd; Alice Keimweiss; Anne Leith; Erica Luna; Julia Mandle and Cees de Bever; Jose (Angel) Mendez; Diana Periton; Veronica Pesantes; Sally Peters; Jane Phillips; Charmaine Picard; Mariana Saforcada; Whitney Scott; Juliet Sorce; Abigail van Straaten; Patricia Sukmonowski and Michael Bral; Jennifer Zitron Suomi; Stefanie Syet; Charles Thornton; Patricia Coomey Thornton; Maria Consuelo Tohme; Mireia Viladoumiu; Owen Warren; Doina Wilson; and the Daniel Young family.

On a more personal note, I would like to acknowledge the frequent encouragement in art given to me by my family when I was a child. My grandmother seemed to treasure every drawing and painting I brought home from school. My aunt Beve presented me with my very first set of Cray-Pas (oil pastels) – 48 colours in a very exotic and professional-looking Japanese wooden box – as well as my first picture encyclopedia of art, a hefty volume filled with glorious images to inspire me. And, of course, my mother enabled me to set up my little art 'studio' where I could experiment freely with colours and materials. She never flinched when I painted black polka dots on the living room walls, fearing their removal might thwart my artistic sensibilities. And she frequently took me to art exhibitions and museums, where she would sit me down and ask me what I thought was going on the paintings. I am so, so grateful.